The Campus History Series

THE UNIVERSITY OF
SOUTH CAROLINA

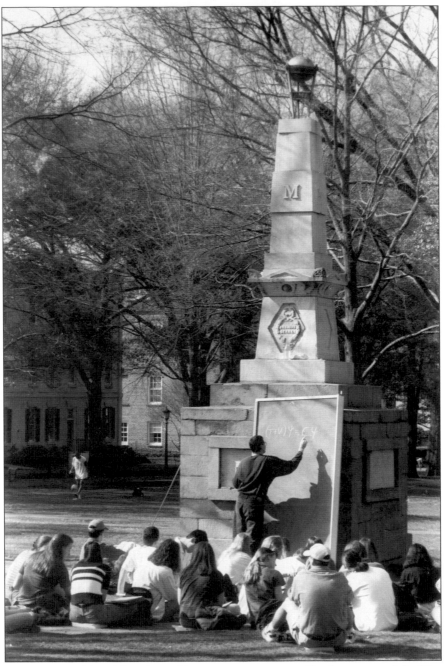

MAXCY MONUMENT, 1980S. The Maxcy Monument was erected in the center of the Horseshoe in honor of South Carolina College's first president, Jonathan Maxcy. The monument was designed by South Carolinian Robert Mills, who was the nation's first federal architect.

ON THE COVER: Students lead the commencement procession in 1933. It was a tradition for many years for the students, faculty, administrators, and various dignitaries to process across campus.

The Campus History Series

THE UNIVERSITY OF
SOUTH CAROLINA

ELIZABETH CASSIDY WEST

ARCADIA
PUBLISHING

Published by Arcadia Publishing
Charleston SC, Chicago IL, Portsmouth NH, San Francisco CA

Printed in the United States of America

Library of Congress Catalog Card Number: 2006928106

For all general information contact Arcadia Publishing at:
Telephone 843-853-2070
Fax 843-853-0044
E-mail sales@arcadiapublishing.com
For customer service and orders:
Toll-Free 1-888-313-2665

Visit us on the Internet at www.arcadiapublishing.com

To my husband, Joe, and my family,
for all their love and support.

CONTENTS

ACKNOWLEDGMENTS

I'd like to thank Allen Stokes, director of the South Caroliniana Library, for encouraging me to begin this project; my editor, Adam Ferrell, for his guidance; and my graduate assistant, Judi Wagner, for her invaluable assistance. Very special thanks go to university photographer Keith McGraw, without whom the archives photograph collection would be much poorer. Finally I would like to remember the late George Terry, former dean of the university libraries, for his boundless enthusiasm for USC and South Carolina history; he would have loved this project.

Most of the photographs come from the collection of the University Archives. The recent images of campus buildings are by Keith McGraw.

INTRODUCTION

Chartered in 1801 as South Carolina College, the University of South Carolina (USC) was the first state university to be supported continuously by annual state appropriations. The school actually opened on January 10, 1805, with one building, two faculty members, and nine students. All students followed an identical course of classical study designed not to train them for careers in common trades, but to elevate their minds; the only degree offered was the bachelor of arts.

The college rapidly achieved a reputation for academic excellence and was known as one of the best-endowed and most distinguished colleges in the United States. Its faculty included Francis Lieber, editor of the *Encyclopedia Americana* and author of *Civil Liberty and Self-Government*. By the 1830s, distinguished alumni comprised a large proportion of the state's general assembly. James H. Hammond and Wade Hampton III were the most prominent of a parade of future governors, senators, judges, and generals who graduated during the antebellum period.

The pre–Civil War campus included Longstreet Theatre and all the buildings in the area known today as the Horseshoe (with the exception of McKissick Museum). The Civil War years, however, brought hardship to the institution. The school was forced to close in June 1862, when nearly all of the students left to join the Confederate armed services.

The institution reopened in 1866 as the University of South Carolina and added law and medical schools. Two years later, a new state constitution, mandated by the U.S. Congress to include suffrage for African Americans, was ratified and called for integration of all state-supported schools. However, none enrolled for classes at the University of South Carolina until 1873. Carolina then became the only state-supported Southern university to integrate during the Radical Reconstruction era that followed the Civil War. When the Democrats came to power again in 1877, the university was closed, reorganized, and reopened in 1880 as an all-white institution.

The remainder of the 19th century proved tumultuous for the institution, as it went through several reorganizations and name changes reflecting the political turmoil in the state and the struggle by legislators, administrators, and faculty to define the school's mission. The university also struggled in the 1890s to adjust to the arrival on campus of women and intercollegiate athletics. Finally, in 1906, at the beginning of its second century, it was rechartered for the third and last time as the University of South Carolina, with an operating graduate school.

In sharp contrast to South Carolina College's antebellum elitist philosophy, the new University of South Carolina was dedicated to providing both liberal and professional education to

the people of South Carolina. Efforts to achieve this objective were hampered by the early arrival of the Great Depression in South Carolina. Enrollment declined, some courses were eliminated, and buildings went without repairs. The situation improved greatly in the late 1930s because of grants from federal New Deal agencies. Then America entered World War II, and the campus was virtually transformed into a naval training base. Payments from the navy helped the school continue to function during the war years.

Since the 1950s, the university has developed into a multi-campus system with highly diverse and innovative educational programs. In 1963, the university integrated for the second and final time in a far more peaceful and dignified manner than other Southern schools. In the 1970s, the physical plant experienced a burst of expansion as enrollment skyrocketed, and administrators struggled to deal with student activists—and streakers. The following decade brought great highs for the university with national and international recognition for its academic programs but ended on a sour note due to the scandal surrounding Pres. James Holderman. His successor, John Palms, worked at restoring the university's integrity and credibility. In the last 15 years, the student body has become more diversified, private support has reached unprecedented levels, and outside research funding has increased significantly. The University of South Carolina marked the beginning of the 21st century by celebrating its 200th birthday and by beginning another period of dynamic growth and change.

One

THE FIRST CENTURY

*An ACT to establish a College at Columbia.
Whereas the proper education of youth contributes greatly to the prosperity of Society, and ought always to be an object of Legislative attention, And whereas, the establishment of a College in a central part of the State, where all its youth may be educated, will highly promote the instruction, the good order, and the harmony of the whole community.*

ACT TO ESTABLISH SOUTH CAROLINA COLLEGE, 1801. In 1801, Gov. John Drayton recommended to the South Carolina General Assembly that a state-supported college be established in Columbia. Legislative committees headed by Charles C. Pinckney and Henry W. DeSaussure created "An Act to Establish a College in Columbia," which passed on December 19, 1801. The school opened on January 10, 1805, with one building, two professors, and nine students.

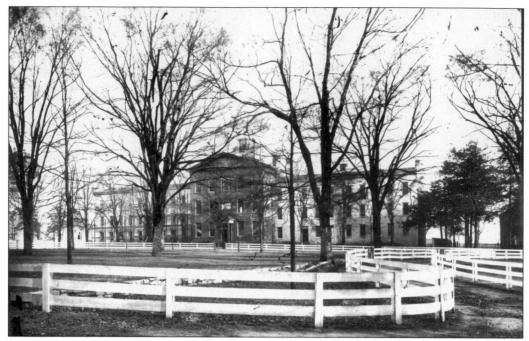

RUTLEDGE COLLEGE, C. 1875. When South Carolina College opened in 1805, this was the only building on campus. It contained student and faculty housing, a library, classrooms, a chapel, and laboratories. Rutledge was heavily damaged by fire in 1855 and quickly renovated and rebuilt. The building is named for brothers John and Edward Rutledge, both of whom served as governor of South Carolina.

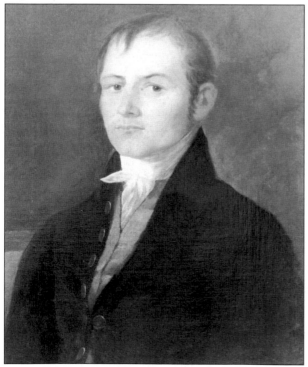

JONATHAN MAXCY. As the first president of South Carolina College, Jonathan Maxcy guided the institution through its formative years. However, the development of curriculum, supervision of faculty, and maintenance of the campus were easy compared to the frequent student disciplinary problems he faced. Maxcy was the first person to suggest that a wall be built around the campus to keep the students in.

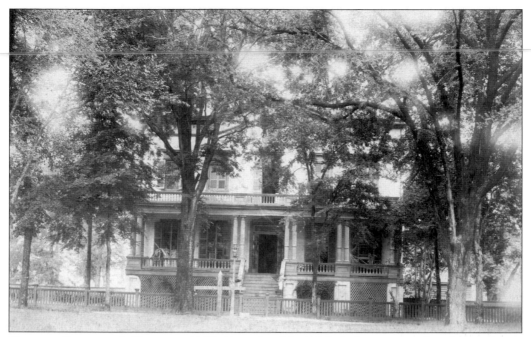

ORIGINAL PRESIDENT'S HOUSE, *c.* **1910.** Completed in 1807, the house served as the residence of every university president from Jonathan Maxcy to William S. Currell. In 1922, the house was converted into offices. Despite its deteriorated condition, it continued to be used until part of the ceiling collapsed in 1937. It was demolished in 1939 during construction of a library, now McKissick Museum, which was built directly behind the old house.

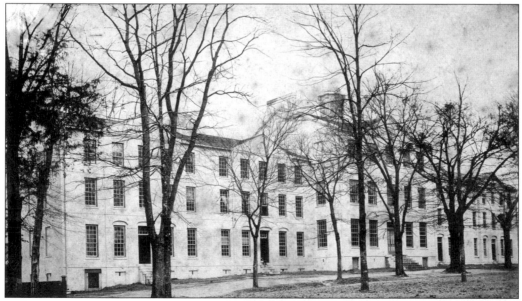

DESAUSSURE COLLEGE, *c.* **1885.** DeSaussure is the second oldest building on campus, constructed in 1809. It was severely damaged by an earthquake in 1811 and had to be reinforced with iron rods. After the Civil War, a portion of the building was used as a federal military prison. It is named for Henry William DeSaussure, director of the U.S. Mint and South Carolina legislator.

EUPHRADIAN LITERARY SOCIETY CONSTITUTION, 1806. Elocution, the study and practice of public speaking, was an important part of the antebellum South. The college's original student organizations, founded in 1806, were debating groups—the Clariosophic and Euphradian Societies. Nearly every antebellum student joined one of them. Debates included hot political issues like slavery and national defense as well as social topics such as divorce and the proper ways to court ladies.

	Edmondston Dr	$	cts
March 5th	For speaking above a whisper		25
"	" talking aloud		25
"	" sitting with his foot in the aisle		12½
"	" laughing aloud		25
Feby 27th	" absent last calling of the roll		25
March 5th	" absent first and second calling of the roll		50
26th	" sitting by the fire		25
	Total	1	87½

CLARIOSOPHIC SOCIETY FINES BOOK, 1836. Members of the literary societies occasionally had heated debates over points of procedure and the conduct of the society's members. The societies developed a system of levying fines for improper conduct in the meeting halls. Finable offenses included sitting in an indecent posture, spitting on the carpet, and hitting the person assigned to critique members' orations.

Thomas Cooper. Englishman Thomas Cooper taught chemistry, mineralogy, and political economy. He served as the college's second president from 1821 to 1834. Described by one student as resembling a "wedge with a head on it," Cooper never understood the Southern youth and their ideas of personal honor. As a result, he was not personally popular with his students, who dubbed him "Old Coot." However, Cooper was considered a pioneer in political economy, and his course and writings greatly influenced the students' political views. It was one of the first political science courses in the United States, and Cooper became known as the "Schoolmaster of States Rights."

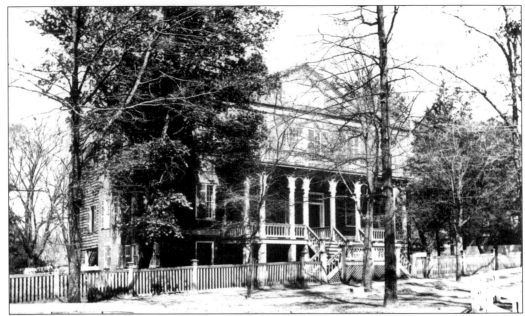

McCutchen House, c. 1875 (Top) and 1920 (Bottom). McCutchen was the second faculty residence built on campus and has perhaps gone through the most changes in its appearance. Among the faculty members who lived there was Maximilian LaBorde, who found the size of the residence uncomfortable for his family of 10 children. After World War II, the building was converted into academic use. During extensive renovations to the Horseshoe buildings in the 1970s, McCutchen was refurbished as a faculty club, which closed in 2002. McCutchen now houses the Culinary Institute at Carolina and food service laboratories for the School of Hotel, Restaurant, and Tourism Management. It is named for faculty member George McCutchen, who lived in the house from 1915 until the 1940s.

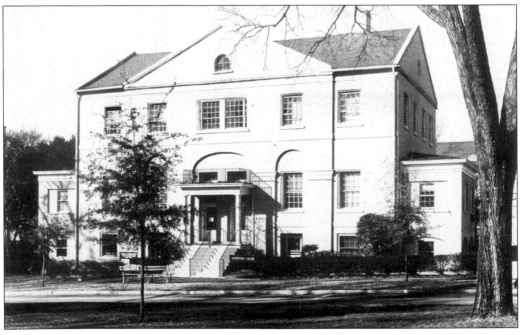

FRANCIS LIEBER. Francis Lieber was the institution's most illustrious scholar. Before joining the faculty of South Carolina College (SCC), Lieber founded the *Encyclopedia Americana* and was an internationally known professor of history and political economy, which he taught at SCC from 1835 to 1855. Nicknamed "Old Bruin" by his students, Lieber was tough, hot-tempered, and impulsive; he once tried to have a student expelled for stupidity.

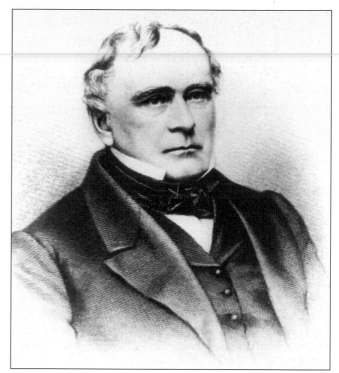

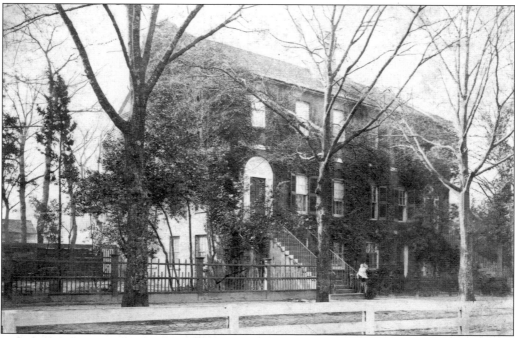

LIEBER COLLEGE, C. 1875. Constructed in 1837, Lieber College was the third faculty double-residence built on campus. The Georgian-style house was continuously used as a faculty residence until the 1940s, when the university stopped providing housing for its faculty. It was then converted into classrooms and offices. The building is named for Francis Lieber, who lived in the building from its construction until his departure from the college.

15

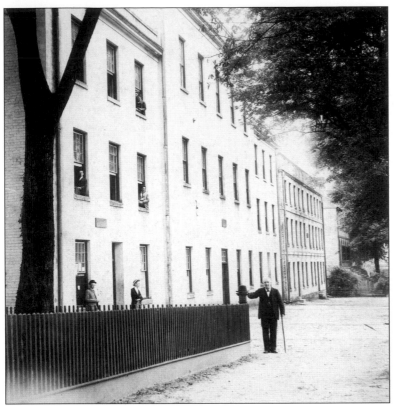

PINCKNEY AND LEGARE COLLEGES (TOP); HARPER AND ELLIOTT COLLEGES, C. 1900 (BOTTOM). Student residence halls Pinckney and Elliott were constructed in 1837 in response to increased enrollment. Harper and Legare were added in 1848 and built flush against the earlier buildings, giving the illusion of two buildings instead of four. In addition to student housing, Harper and Legare provided office and classroom space. The buildings were named for the following South Carolinians: South Carolina governor and U.S. senator Charles Pinckney; legislator and diplomat Charles Cotesworth Pinckney; U.S. attorney general and U.S. congressman Hugh Swinton Legare; president of the Bank of the State of South Carolina Stephen Elliott; and judge and U.S. congressman William Harper.

16

ADDITIONS to the COLLEGE LAWS,

ADOPTED BY THE

BOARD OF TRUSTEES,

AT THEIR ANNUAL MEETING IN DECEMBER, 1836.

———

1. Students are strictly forbidden to visit Taverns, Hotels, or places of Public Amusement, without special permission first obtained from the President.

2. Students are strictly forbidden to visit Eating-Houses, or Grog Shops, on pain of suspension or expulsion, as the nature of the case may require.

3. Students are strictly forbidden to smoke in any of the public rooms or halls of the College, in the Campus, or in the streets of Columbia.

4. From the first of May until the close of the term, the Students shall be dismissed after evening prayers, until 8 o'clock at night; at which time, they shall return to their rooms for the purpose of study, and remain in for the night.

5. Immediately after Commencement in every year, the Faculty shall assign rooms in the College-buildings, to each of the Students.

6. There shall be two Public Examinations of the Senior Class in each year: the first, on Tuesday, after the third Monday in June; the second, three weeks before Commencement; and also, two Public Examinations of all the other Classes; the first, immediately preceding the Examination of the Senior Class in June, and the second, beginning one week before Commencement.

7. The Faculty are authorized to employ two additional servants, if they shall deem that number necessary, one for the Laboratory, and one to sweep the rooms and make the beds of the Students.

COLLEGE LAWS, 1836. When the South Carolina College was established, the board of trustees adopted strict regulations regarding student behavior that forbade drinking, gambling, and cockfighting—all common social activities in 19th-century South Carolina. As a result, student discipline was a constant problem.

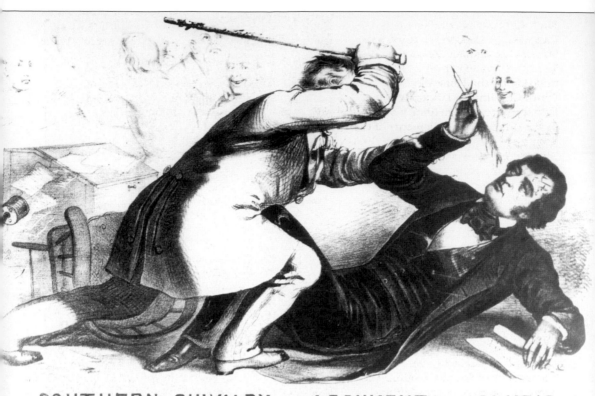

SOUTHERN CHIVALRY — ARGUMENT VERSUS CLUB'S.

PRESTON S. BROOKS. A habitual disturber of the peace at the college in the late 1830s was future U.S. congressman Preston S. Brooks. The final straw came in 1839, when Brooks was about to graduate. After hearing an exaggerated report that his brother was being mistreated at the Columbia jail, Brooks stormed the jail with a pair of pistols. The police disarmed him and the trustees expelled him. Brooks went on to become a U.S. congressman. In 1856, Massachusetts senator Charles Sumner delivered a speech on slavery in which he insulted Brooks's cousin, Sen. A. P. Butler. Brooks responded by beating Senator Sumner with a cane on the floor of U.S. Senate. He was reelected without opposition. The cartoon above mixed up the two legislators. Sumner was an elderly man.

MAIN READING ROOM, SOUTH CAROLINIANA LIBRARY, _c._ 1899, AND SOUTH CAROLINIANA LIBRARY, _c._ 1940. The most architecturally distinctive building on the Horseshoe, the South Caroliniana Library was the first separate college library building in the United States. Elements of the design are attributed to famous 19th-century architect Robert Mills. The main reading room on the second floor is a replica of the Library of Congress reading room designed by Charles Bulfinch, which was destroyed by fire. Two fireproof wings designed by J. Carroll Johnson were added in 1927. The bricks of the wings in this 1940 image have not yet darkened to match the rest of the building. After serving as the university library for 100 years, the building became a repository for published and unpublished materials relating to the history, literature, and culture of South Carolina. The name Caroliniana means "things pertaining to Carolina."

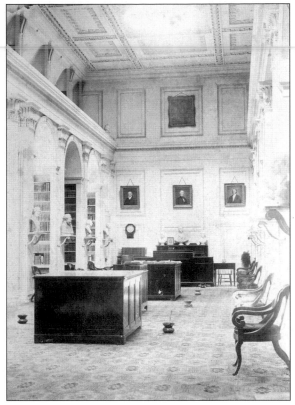

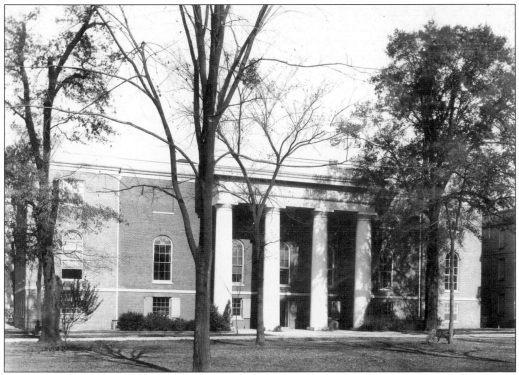

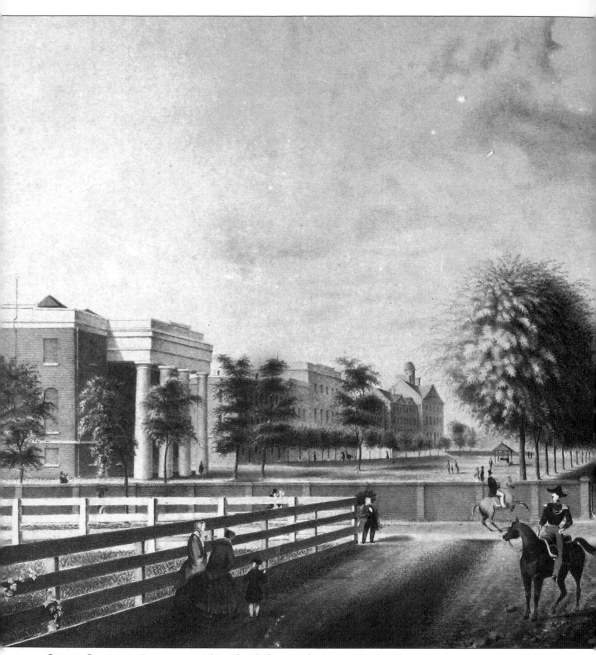

SOUTH CAROLINA COLLEGE, 1850. This lithograph shows the brick wall constructed in 1835 to replace the wooden barriers that surrounded the campus in a largely unsuccessful effort to deter students from leaving the campus and engaging in ungentlemanly behavior—such as stealing turkeys from Columbia residents and visiting local taverns. Although the wall failed in its original purpose, it never rendered finer service than near the end of the Civil War,

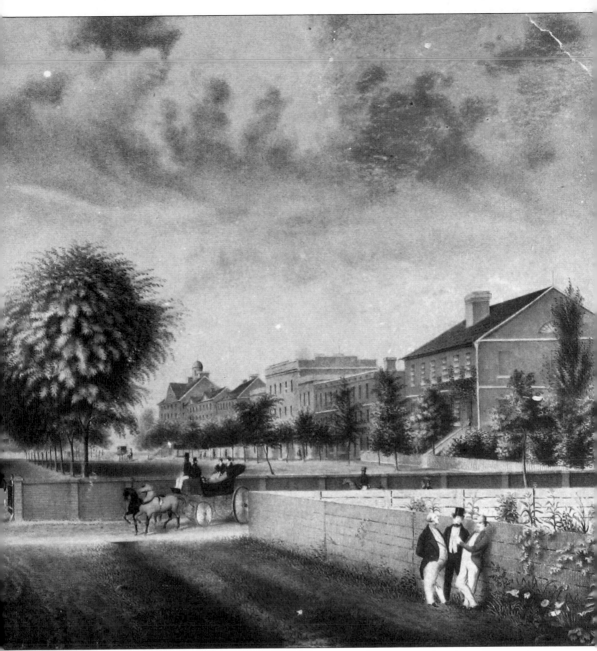

when the flames that engulfed Columbia in February 1865 swept right up to the campus. The brick barrier helped prevent the fire from reaching the college buildings. Near of the end of the 19th century, the center portion of the wall was lowered, and it was later topped with iron railing.

21

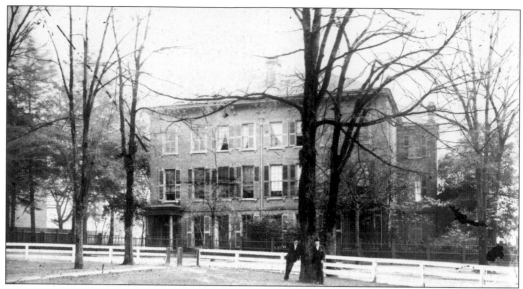

PRESIDENT'S HOUSE, C. 1875 AND TODAY. This structure originally served as a faculty double residence. It was constructed in 1854 on the site of an earlier faculty dwelling dated to 1810, which was demolished due to poor condition. The current structure served as a faculty residence until the 1940s, when it was converted into a women's residence hall. In 1952, it underwent extensive renovations, financed by private contributions, in order to convert it into a single dwelling to become the official USC President's House. Pres. and Mrs. Donald S. Russell led the renovation project, which included the addition of enclosed porches on the second and third floors, a library, and a reception room. Pope John Paul II stayed at the President's House during his visit to the university in 1987.

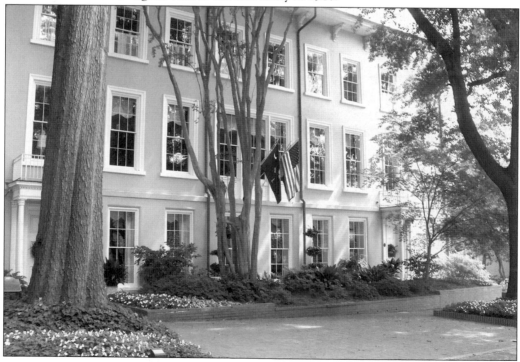

CLASS OF 1852. Food was a major source of student dissatisfaction. Students were required to eat at the campus dining facility, which frequently served wormy biscuits and rancid meat. After years of complaints, students staged the Great Biscuit Rebellion of 1852: of the 199 students, 109 signed an honor-bound agreement that if the compulsory system was not abolished they would all quit the college. The trustees refused to comply, so all 109 students left.

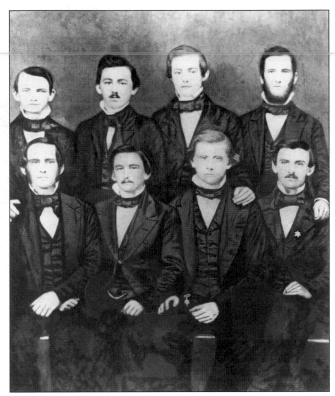

CADET CAPTAIN JOHN H. GARY. South Carolina College students formed a cadet corps in 1825. The state provided weapons and ammunition, and the college purchased textbooks relating to military training. After the Civil War broke out, nearly the entire student body quit school and joined Confederate units, forcing the college to close its doors in the fall of 1862. Cadet captain John H. Gary was killed defending Battery Wagner near Charleston.

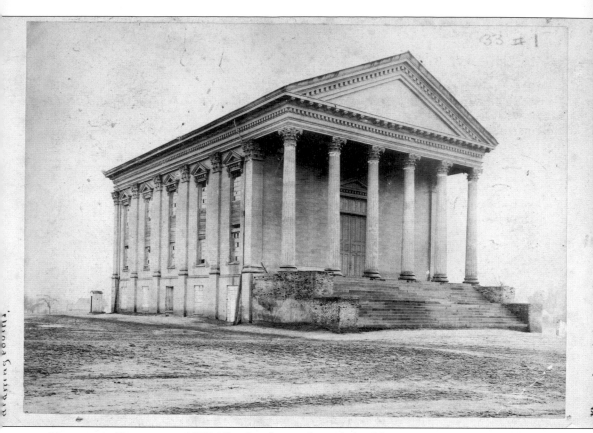

LONGSTREET THEATRE, C. 1875. The Greek temple–style building was constructed in 1855 as a chapel and auditorium for South Carolina College but suffered bad luck from the beginning. Its construction was completed two years late, the roof blew off twice, and it suffered from poor acoustics that were apparently uncorrectable. During the Civil War, it and other buildings on campus served as a Confederate hospital. It was converted into a science facility in 1888, a gymnasium in 1893, and finally a theater-in-the-round in 1976. The building is named for Augustus B. Longstreet, a colorful and controversial jurist, writer, and educator who served as president of South Carolina College from 1857 to 1861. The caption on the right margin of this image reads: "New chapel, head Sumter Street, battered by Sherman."

24

MAXIMILIAN LABORDE. Maximilian LaBorde joined the faculty of South Carolina College in 1843 after serving as a state legislator, college trustee, and secretary of state of South Carolina. LaBorde taught belles lettres and logic. As chairman of the faculty, LaBorde headed the college during the Civil War years (1861–1865), dealing with Confederate—and later Union—authorities regarding the use of the college buildings as a hospital.

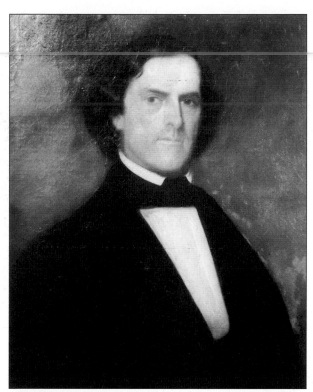

USC FACULTY, 1868. The new university opened its doors on January 10, 1866, with a new curriculum that allowed a choice in degree programs. Among the faculty members were the renowned scientists and brothers John and Joseph LeConte. John LeConte taught astronomy as well as natural and mechanical philosophy; Joseph taught chemistry, mineralogy, geology, and the new field of pharmacy. Other new courses included civil and military engineering, stone cutting, and architecture.

AFRICAN AMERICAN STUDENTS ON THE HORSESHOE, 1875, AND CLARIOSOPHIC ROLL BOOK, 1880.
USC became the only state-supported Southern university to integrate during the Radical Reconstruction era that followed the Civil War. By 1876, the student body was predominately African American, and a number of future leaders graduated from the school. The first African American graduate, T. McCants Stewart, became an associate justice on the supreme court of Liberia. Other black graduates became prominent ministers and college presidents. After Wade Hampton was elected governor and whites regained control of state government, the university was closed for reorganization in 1877 and reopened in 1880 as an all-white institution. When white students returned to the school, members of the literary societies ripped or marked out the pages in their debate and roll books that had been used by the black students during Reconstruction.

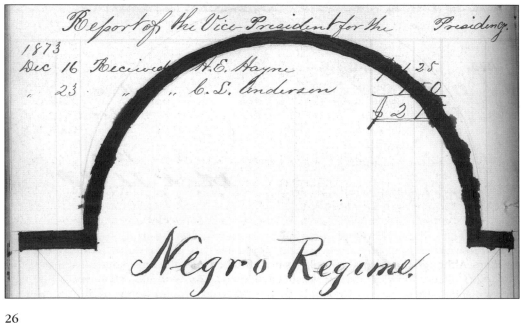

RICHARD GREENER. Carolina's first black faculty member was Richard Greener, who taught mental and moral philosophy and served as the college librarian. Greener was the first African American graduate of Harvard University and one of the first African Americans to graduate from Carolina's law school. He later entered the U.S. diplomatic corps, serving as the first U.S. consul to Vladivostok, Russia, from 1898 to 1905.

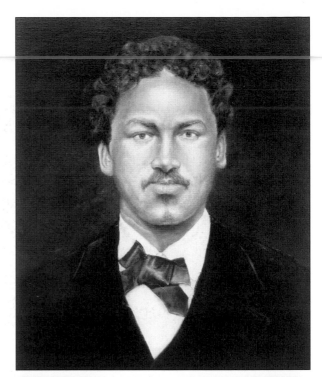

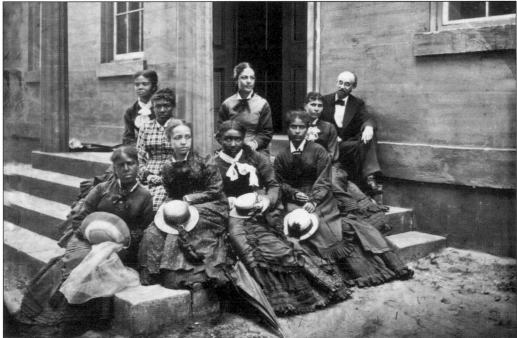

STUDENTS AND FACULTY MEMBER OF THE NORMAL SCHOOL, *C.* 1875. During Reconstruction, the state legislature passed a bill creating a state normal school for the training of public school teachers. Although the normal school was not affiliated with the university, it was housed in Rutledge College, and university professors delivered lectures on subjects such as chemistry, biology, and mathematics. Its student body was made up almost entirely of black females.

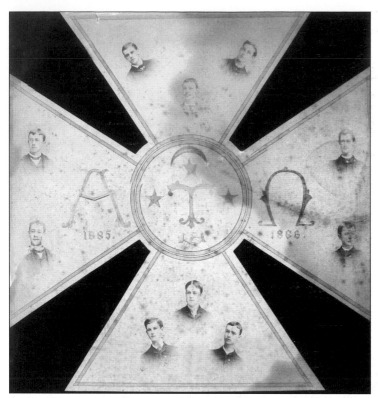

ALPHA TAU OMEGA, 1885, AND A CARTOON DEPICTING THE FRATERNITY BAN. The first fraternity chapter was established at the South Carolina College in 1850, but it was not until the early 1880s that fraternities became popular enough to challenge the established social dominance of the literary societies. In the early 1890s, friction developed between the Greeks and the Barbarians (non-fraternity students), culminating in a petition in 1896 asking the board of trustees to abolish the Greek-letter societies. The Barbarians accused the Greeks of acting socially superior, encouraging dishonest behavior, and damaging college spirit. The battle also reached the floor of the state legislature, and in 1897, the legislature passed a law banning all Greek-letter fraternities from all state-supported colleges.

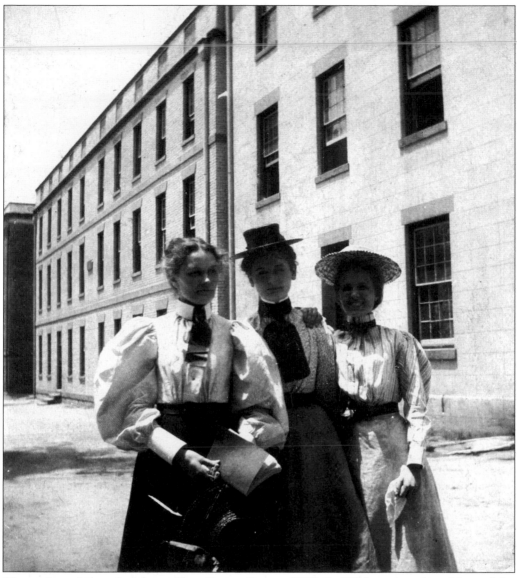

MATTIE JEAN ADAMS (LEFT) AND TWO OTHER COEDS, 1898. In 1894, against the wishes of the trustees, faculty, and students, the state legislature required that the South Carolina College admit women. One year later, Francis Guignard Gibbes was the first woman to enroll in a course. Gibbes, a Phi Beta Kappa, went on to become a successful playwright and poet, earning national and international recognition for her work. Her play *The Face* was developed into a motion picture. She married Oscar L. Keith, professor of modern languages at USC, in 1911. In 1898, Mattie Jean Adams was the first female to graduate from Carolina. She later attended Oxford University, earned her masters of arts degree from Columbia University, and received an honorary doctor of literature degree from Meridian College, where she served as the head of the Department of English for 18 years. Only a handful of coeds attended full-time until World War I, as the college made no effort to attract them or provide facilities such as housing.

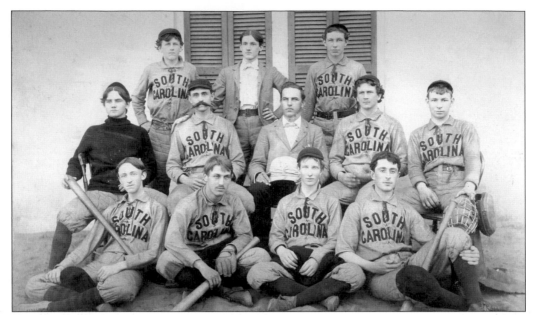

BASEBALL TEAM, 1896. Baseball was the first sport to attract student interest in the early 1880s. Intramural college teams played each other and against teams of city firemen, police, and mechanics. Intercollegiate contests began in the 1890s, but USC did not officially permit such competitions until 1895. This 1896 photograph is the earliest known image of a Carolina baseball team.

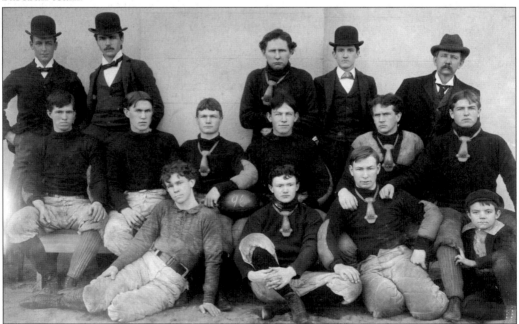

FOOTBALL TEAM, 1896. Football arrived on campus a few years after baseball. Carolina played its first intercollegiate game in 1892 against Furman University; Furman won 44-0. This photograph is of the first Carolina football team to play Clemson University. Carolina won 12-6. The items around the players' necks are nose guards, which extended from the forehead down to the chin.

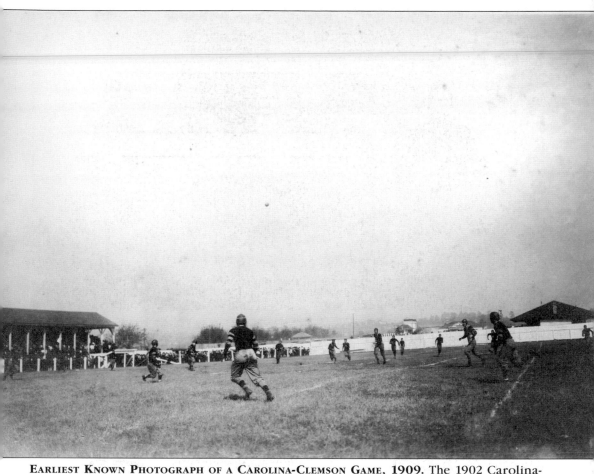

EARLIEST KNOWN PHOTOGRAPH OF A CAROLINA-CLEMSON GAME, 1909. The 1902 Carolina-Clemson football game sparked a near riot and provided the roots of a Carolina tradition. When Carolina scored an upset 12-6 victory over Clemson, students paraded down Main Street with a banner depicting a crowing rooster over a beaten tiger. The Clemson Cadet Corps, armed with bayonets and swords, marched on the campus with the intent of seizing the banner. Several dozen Carolina students hastily armed themselves with clubs, rocks, and a few pistols and hunkered down behind the low brick wall and prepared to defend their alma mater. Among them was future USC president J. Rion McKissick. Faculty members and police intervened, and a compromise was reached: the banner was burned between the two groups of students while they cheered each other—the first tiger burn. The Carolina-Clemson game was suspended until 1909. It was also around 1902 that the Carolina teams became known as the Gamecocks.

JOHN M. MCBRYDE, *c.* **1900.** John M. McBryde is the only person who has served as Carolina's president twice. His first term was from 1882 to 1883, and he served again from 1888 to 1891. He served as chairman of the faculty between those two terms. McBryde guided the institution through difficult times as it tried to recover from the effects of the Civil War and Reconstruction and underwent several reorganizations due to a tumultuous political climate.

BENJAMIN SLOAN, *c.* **1900.** West Point graduate and Civil War veteran Benjamin Sloan came to Carolina in 1880 and taught mathematics, physics, engineering, and astronomy. He served as president of the institution from 1903 to 1906. It was during his administration that the upheavals of several reorganizations ended and the school was chartered as the University of South Carolina for the third and final time in 1906.

Two

COLLEGE TO UNIVERSITY

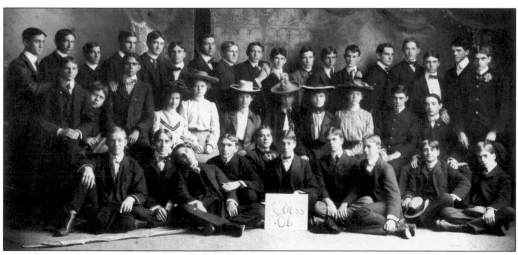

CLASS OF 1906. This was the first group of students to graduate from the current University of South Carolina. As freshman, they entered the South Carolina College, primarily a liberal arts school. With the institution's final reorganization in 1906, Carolina began the long process of developing into a modern research university.

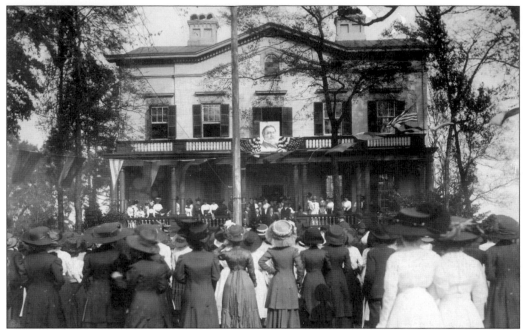

U.S. PRESIDENT TAFT AT USC, 1909. In 1909, William Howard Taft became the first sitting U.S. president to visit the Carolina campus. A large crowd of faculty, students, and Columbia residents gathered on the Horseshoe to hear him speak from the steps of the university's original president's house.

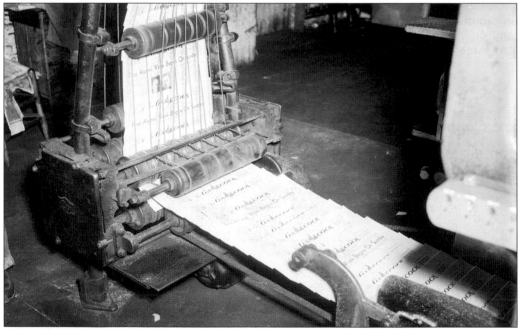

GAMECOCK **NEWSPAPER COMING OFF THE PRESSES, 1940s.** The *Gamecock* student newspaper first appeared on January 30, 1908. It was established by the Clariosophic and Euphradian literary societies, who also published a literary magazine called the *Carolinian*. The newspaper eventually broke away from the societies when their influence on campus declined.

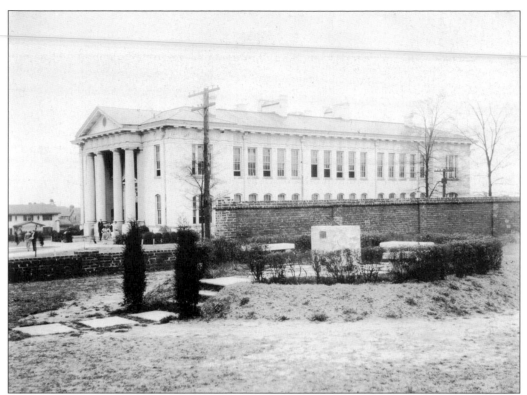

DAVIS COLLEGE, 1920S. Davis College's construction in 1909 made it the first new building on campus since before the Civil War. It was originally built to house the Department of English. It is named for longtime faculty member R. Means Davis, for whom Davis Field is also named. Davis taught history, political economy, and law.

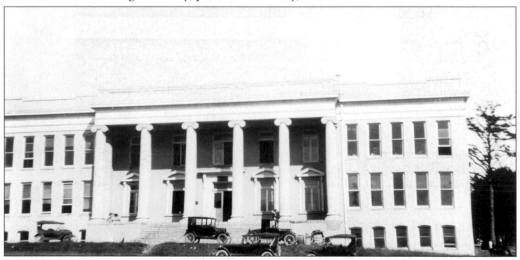

BARNWELL COLLEGE, 1920S. This 1910 structure was the second 20th-century building added to the campus. It was originally a science hall named for 19th-century scientists and faculty members John and Joseph LeConte. In 1952, a new science hall was built and the LeConte name transferred. The old science hall was then renamed for Robert W. Barnwell Sr., the third president of South Carolina College.

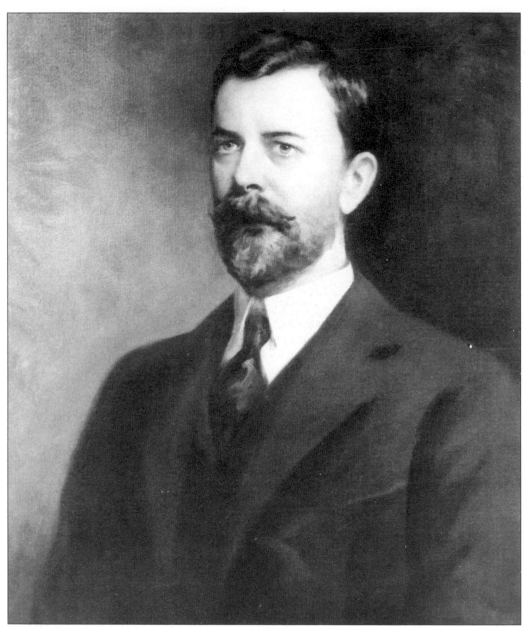

ANDREW CHARLES MOORE. An 1877 graduate of South Carolina College, Andrew Charles Moore served as a primary school principal, superintendent of schools in Spartanburg, South Carolina, and professor of botany at the University of Chicago before joining the faculty of his alma mater in 1900. In 1905, he became the first chair of the Department of Biology, and in 1907, he established the USC Herbarium with his own collections. Moore was called upon twice to serve as interim president of the university, from 1908 to 1909 and 1913 to 1914. Moore also headed a project to collect biographical information on the school's alumni and published a list of the students that attended South Carolina College from 1805 to 1905. The botanist had great affection for the university's campus and gardens. He died in his home in Lieber College on the evening of September 17, 1928. That same evening, a terrible storm blew down his favorite tree on the Horseshoe; it fell on Lieber College.

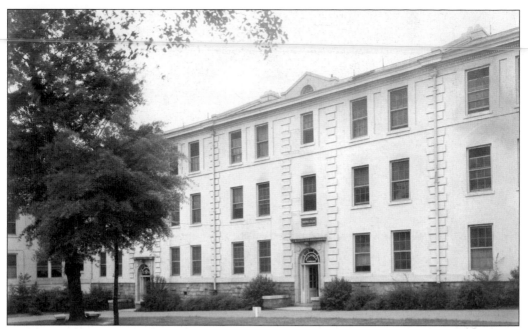

THORNWELL COLLEGE, 1950s. Upon its completion in 1913, Thornwell College was the first resident hall to be built at the university in 65 years. New wings were added in 1937 as part of a construction program funded by the federal Works Progress Administration, a New Deal agency. It is named for alumnus James H. Thornwell, who served as president from 1851 to 1855.

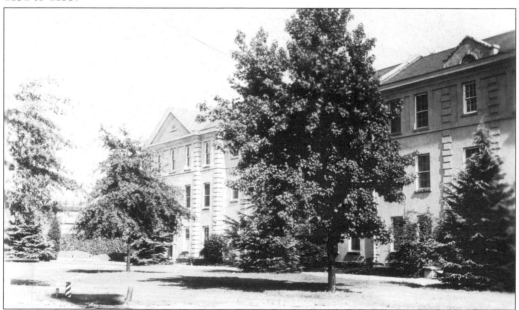

WOODROW COLLEGE, 1950s. This 1914 residence hall was one of four buildings designed by university architect Charles C. Wilson before the position was abolished in 1915. Woodrow was the first dormitory with central heating. It was used as a hospital during the influenza pandemic of 1918. The building was named for James Woodrow, who served as university president from 1891 to 1897 and guided the school through difficult financial times.

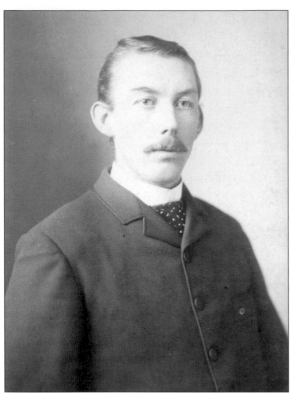

GEORGE A. WAUCHOPE, C. 1900. English professor George A. Wauchope joined the faculty in 1898 and taught for 45 years until his retirement in 1943. He is perhaps best known for writing the university's alma mater, "We Hail Thee Carolina." The administration sponsored a contest in 1911, and Wauchope submitted the winning entry.

SHAKESPEAREAN PAGEANT, 1916. The joint university and community commemoration of the 300th anniversary of Shakespeare's death had a cast of 900 costumed participants, including faculty and students. Two thousand spectators attended the two performances: a London May Day in Elizabethan England, held on the Horseshoe (below), and an evening costume ball at which scenes from Shakespeare's plays were performed.

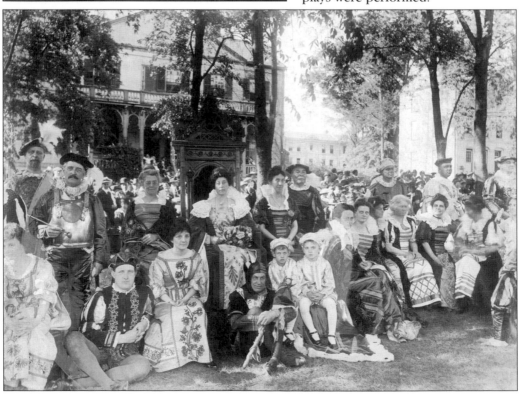

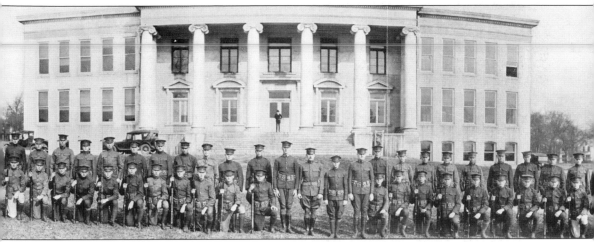

ROTC IN **FRONT** OF **BARNWELL** **COLLEGE,** *C.* **1918.** America's entry into World War I in 1917 prompted the establishment of a Reserve Officer Training Corps (ROTC) unit at Carolina. This was the first time military training returned to the campus since the Civil War. At the start of the 1917–1918 academic year, three-fourths of the student body joined the ROTC, turning USC into a virtual training camp. The university adjusted its curriculum to meet the demands for certain types of training, including the addition of Red Cross courses. The Great War seriously crippled Carolina's teaching effectiveness; by the fall of 1918, nearly half of the faculty members had been released from their teaching duties to serve in the armed forces or perform other war-related work for government agencies. After the war's end, the university administration saw no need to continue the ROTC and abolished the program in 1921.

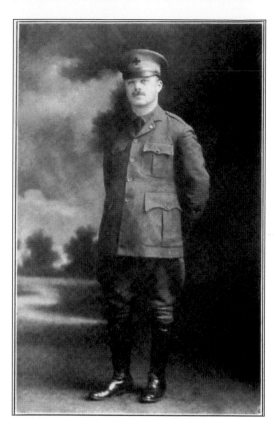

JOSIAH MORSE, 1918. Philosophy professor Josiah Morse was tapped to head the South Carolina Red Cross during World War I. He arrived at Carolina in 1911 and served as the only faculty member of the Department of Philosophy for several years. Morse expanded the department during his 35 years of service to the university, including the addition of courses on the psychology of religion and race problems in the South.

RICHMOND H. HILTON, 1924. After the war, Carolina welcomed a number of veterans as students, including Richmond H. Hilton, a recipient of the Medal of Honor. In leading an attack on a German machine-gun nest, Hilton advanced well ahead of his men and personally killed 6 and captured 10 of the enemy. The wounds he received in this action resulted in the loss of an arm.

ARTWORK FROM THE 1918 *GARNET AND BLACK* YEARBOOK.
Patriotic fervor swept through the students, who
viewed the war as a great romantic adventure. They
filled campus publications with articles, artwork, and
poetry promoting one's duty, honor, and service to
God and country.

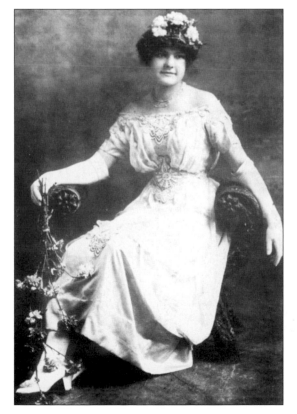

EASTER QUEEN, 1914. The Easter
queen was elected during Easter week
festivities, which included the German
Club ball. Named after a type of dance,
the German Club balls were the
highlights of the social calendar and
were held at Thanksgiving, Christmas,
Easter, and commencement (known as
the June Ball).

41

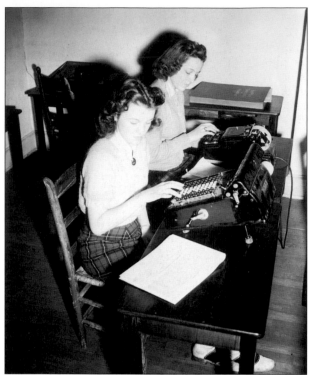

COMMERCE STUDENTS, *C.* 1940. The university established a School of Commerce in 1919. Initially few female students majored in the regular business program, opting instead for secretarial science. The secretarial coursework was dropped in the 1940s, and the name changed to School of Business Administration. In 1998, the school was named for alumna and benefactor Darla Moore.

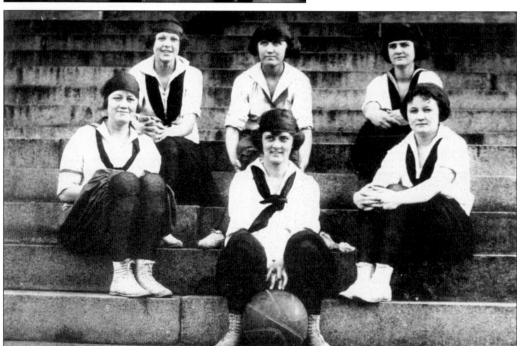

COED BASKETBALL TEAM, 1921. Just a few years after women were admitted to the university, they founded their own sports teams. However, the teams were essentially intramural clubs and did not compete on an intercollegiate basis. In the first several decades, the coeds dressed modestly in long skirts for tennis and bloomers and heavy stockings for basketball.

IRENE DILLARD ELLIOTT, C. 1925. English professor Irene Dillard Elliott was one of the first women to receive a Ph.D. from the University of North Carolina. She joined the USC faculty in 1924 and was appointed as Carolina's first dean of women. She left the university in 1935 due to ill health but returned in 1946. Elliott taught English at Carolina until her retirement in 1964.

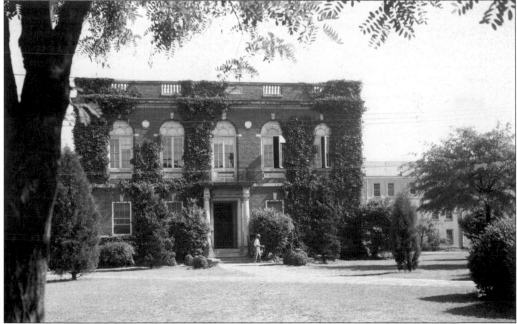

CURRELL COLLEGE, 1940s. Currell College was constructed in 1919 as the university's law school and was originally named Petigru College. The names under the windows commemorate noted South Carolina lawyers and judges. When a new law school was built in 1950, the name Petigru was transferred to the new building, and the old building was renamed for William Spenser Currell, USC's president from 1914 to 1922.

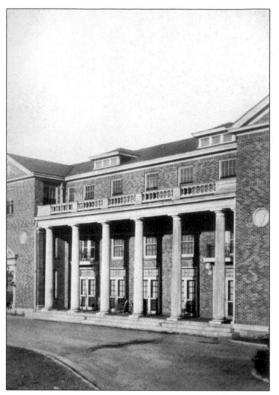

ORIGINAL WADE HAMPTON COLLEGE (TOP) AND LOBBY, C. 1930. The original Wade Hampton dormitory was the first women's residence hall built at Carolina. Until World War I, women had not attended in great numbers, and no housing was provided for them. However, the reduction of the number of male students during the war forced university administrators to offer women's housing in a wing of DeSaussure College. After the war, women continued to press for separate housing on campus, and the first Wade Hampton College was built in 1924. The building was razed in 1959, and the current Wade Hampton dorm built on the same site.

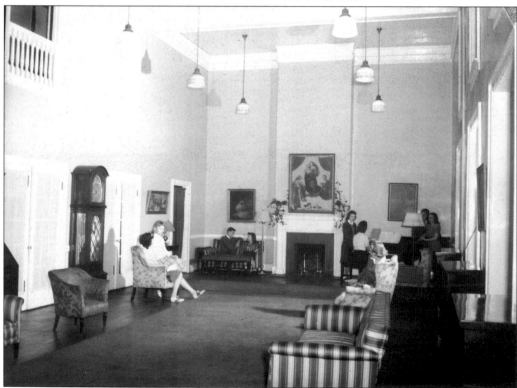

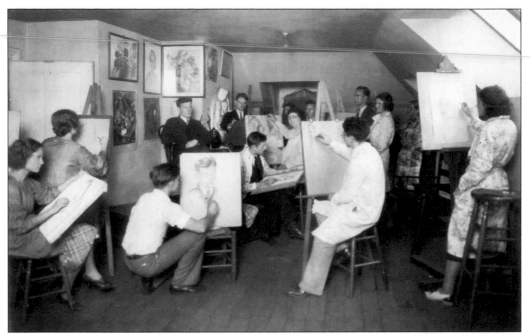

ART CLASS, c. 1930. The university established its Department of Fine Arts in 1925 under Katherine B. Heyward, one of the first female faculty members at the university and the first female department head. Two years later, she was joined by Catharine P. Rembert, the first graduate of USC's art department. Heyward retired in 1945 after 20 years on faculty; Rembert retired in 1967 after 40 years of service.

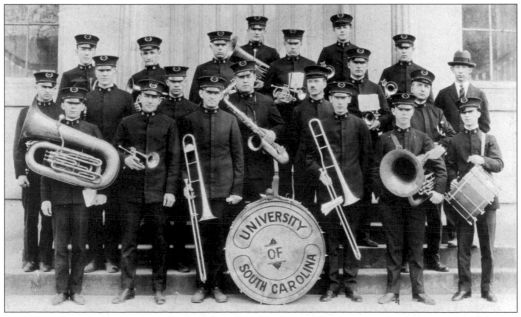

USC's FIRST UNIFORMED BAND, 1924. The Department of Music was established in 1924, and the university band officially came into existence that same year. For the first few years, the band remained small and included faculty members, but it soon became a prominent part of the university's athletics and homecoming activities.

45

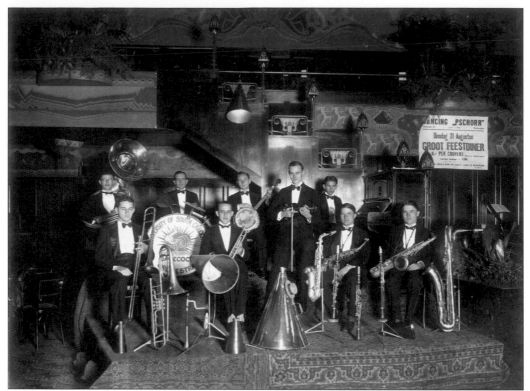

GAMECOCK ORCHESTRA IN EUROPE, LATE 1920S. The Gamecock Orchestra was founded in 1924 by a group of students. In addition to playing at student dances into the 1930s, the orchestra toured the United States and Europe in the late 1920s. Following a performance on the French Riviera, a reporter wrote that the "rattling good jazz outfit . . . played as lively music as could be heard anywhere."

CAROLINA'S FIRST FEMALE CHEERLEADERS, 1931. The university's cheerleaders were originally male, but in 1931, three female students joined the squad. They lead organized cheers and formed pep squads to boost school spirit. Their duties gradually become more athletic and acrobatic, and their modern uniforms are a far cry from the long skirts and sweaters that were worn through the 1950s.

Order of the Sons of Schlitz

OBJECT:
To Beer up under our numerous college duties.

PLACE OF MEETING:
Under the Anheuser-Busch.

SIGN: Blue Ribbon.

FAVORITE PLANT: Hops.

MOTTO:
"With few equals in the art—no limit."

Members

TRAHRU GONIL NOHJ LIPHMEHL

DWALRAW STIHM MALIWIL SEJMA

YOLPL PTRARO ODSOW NADRAG

SUB ROSA FRATERNITIES, 1908 (TOP) AND 1927 (BOTTOM). During the 30-year ban on Greek-letter societies, many fraternities became underground, or sub rosa, organizations and assumed the guise of campus clubs; some chose unusual names like the ones here. There were efforts to reintroduce fraternities to South Carolina colleges, and in 1920, a bill to lift the ban was narrowly defeated in the state legislature. When the ban was finally lifted in 1927, these clubs quickly petitioned to become chapters of national social and honor fraternities. The first sororities were also established on campus, and in the next few years, there was rapid growth in the number of Greek chapters. The level of student participation in Greek societies peaked in the 1940s and 1950s.

Land of Mochhdamwrest-Emperor's Court

Emperor "Joshua" Ready	Chief High Mogul
Lord "Tyte Wad" Sherrill	Chancellor of Exchequer
Lord Marshall "Sip" Derrick	Captain of King's Guard
Archbishop "Einstein" Ready	Archbishop of Summerset
Baron "Fatty" Millard	Prime Minister
"Hot Air" Thomas	Herald
"Beef Trust" Smith	Castle Cook
"Mumps" Hope	King's Butler
"Cornfield" Smith	Royal Sheriff
"Tid Israel" Dowling	Court Jester
Squire "Slouch" Hankins	Chief Groom
Duke "Propaganda" Chewning	Duke of Bath and Attendant to the King
Duchess "Mary" Williams	Duchess of Bath and Attendant to the Queen

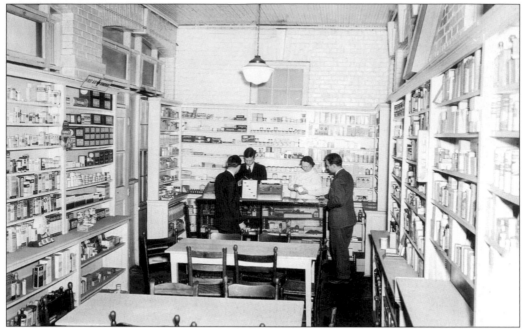

MODEL DRUGSTORE, SCHOOL OF PHARMACY, C. 1940. The first effort at a School of Pharmacy in 1888 lasted only three years, although classes continued to be offered. The school was reestablished in 1925 and immediately came under debate as to whether it was necessary, since the Medical University of South Carolina already had one. In this image, pharmacy students practice their newly learned skills in the school's model drugstore.

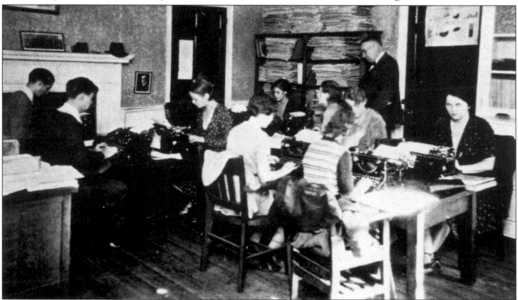

JOURNALISM STUDENTS AT THEIR TYPEWRITERS, 1930s. The School of Journalism was established in 1923, with the *State* newspaper editor W. W. Ball as dean. In 1927, the university again recruited a professional newspaperman to head the school—former USC trustee and future president J. Rion McKissick. Classes were first held in the original President's House at the head of the Horseshoe.

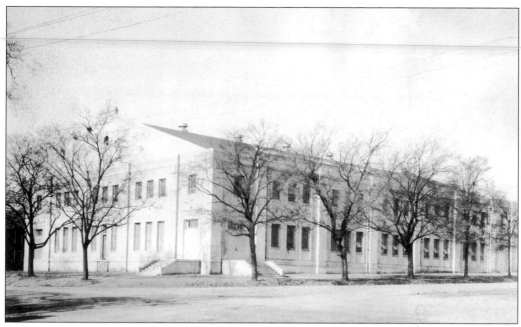

OLD FIELD HOUSE, LATE 1920s. In 1927, the university constructed what was then considered to be one of the finest basketball arenas in the South. The original Field House seated 3,500 and was located on Sumter Street across from Longstreet Theatre. In addition to basketball, it was used for student assemblies, freshmen orientation, J. Rion McKissick's inauguration as USC president, and May queen ceremonies. As the campus population boomed in the 1960s, it became more difficult to get into the basketball games, though the close quarters added to the noise and excitement of the game. The building was destroyed by fire in 1968.

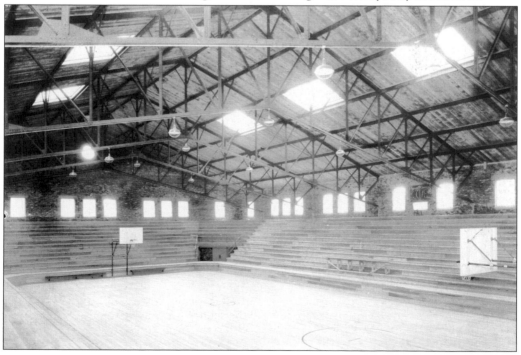

STUDENT BODY TRADITIONS

Every college has certain traditions which are an essential part of college life. You may not like them now. Later you will see the point and will be glad that you followed them.

1—All Carolina men speak to all other Carolina men wherever they meet. Learn to say "Hello" and then say it.

3—All members of the student body stand and remove their hats while singing or while the band plays the Alma Mater.

4—All freshmen must wear the regulation cap throughout their freshman year.

5—No man shall wear a block "C" unless he has been awarded one by the Athletic Board High school letters shall not be worn on the Carolina campus.

7—All Carolina men sit in the "Carolina Cheering Sertion" of the bleachers at football games.

8—Students give preference to those merchants who back Carolina by advertising in the college publications.

9—Colors are worn by all students thruout Fair Week.

10—"We Hail Thee Carolina" is sung only on fitting occasions and with due reverence to the institution.

YMCA Freshman Handbook, 1929. The YMCA was established at Carolina in 1883, primarily as a Bible study group. After Flinn Hall was remodeled to give the Y offices and meeting space, the organization developed into a major influence on campus under the direction of R. G. Bell. The campus Y organized freshman orientation activities and published a freshman handbook from the 1920s into the 1950s. The handbooks included information on administrators, regulations, and social activities. They also included a list of Carolina traditions, like the above page from the 1929 handbook. As the student body grew in the 1960s, the popularity and influence of the Y declined. In 1965, the Y stopped sponsoring the freshman orientation program. Student Affairs gradually took over the orientation work.

BERNARD A. EARLY, C. 1930. October 15, 1927, marked the first time a Carolina homecoming was held on the occasion of a football game. Alumni association secretary Bernard A. Early had noted the rising popularity of football-weekend homecoming at other schools and accurately predicted a strong response from Carolina's alumni. The alumni association had previously arranged various types of alumni reunions, but none had the activities now associated with homecoming.

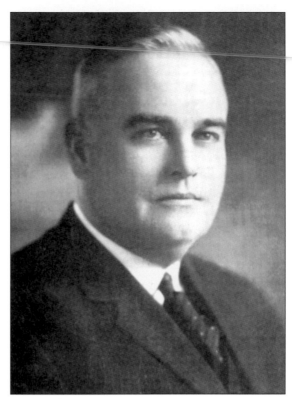

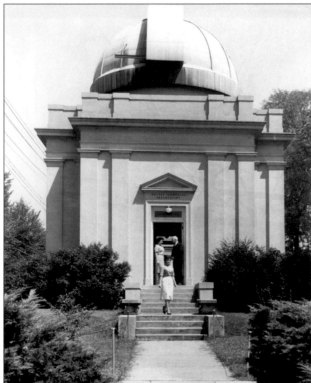

MELTON OBSERVATORY, 1950S. Built in 1928, the observatory was made possible by a gift of $15,000 from Edwin G. Seibels. At the time, it was the largest gift ever made to the university by an alumnus. The observatory has a 16-inch reflecting telescope. It was named for William Davis Melton, who served as president of the university from 1922 until his sudden death in 1926.

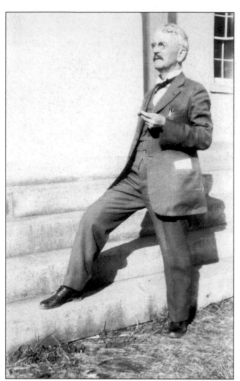

YATES SNOWDEN, *C.* 1930. History professor Yates Snowden joined the faculty in 1906. Known as the "Incarnation of the Old South," he was witty, charming, and one of the most recognizable figures on campus with his snow-white hair and black cape. Snowden disapproved of the growing trend in higher education of requiring professors to have Ph.Ds.

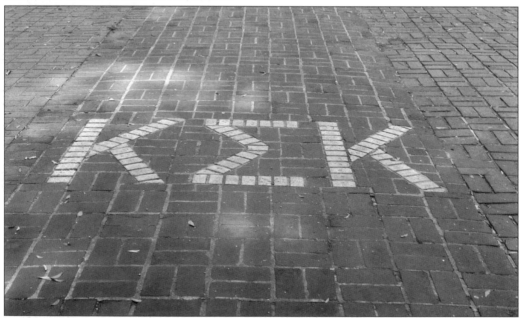

HORSESHOE SIDEWALK. In 1931, students and faculty members, weary of trudging through muddy paths on rainy days, decided to lay sidewalks on the Horseshoe, since the university was unable to obtain funding from the state legislature. The project received donations of money, bricks, and the assistance of brick masons. The initials of the participating student organizations and professors Havilah Babcock and George A. Wauchope are spelled out in white bricks in the sidewalks.

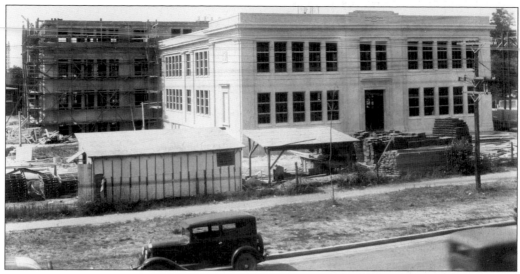

WARDLAW COLLEGE, *C.* **1930 (TOP), AND** *TORCHBEARER* **STATUE, 1970S (BOTTOM).** The construction of this building in 1930 finally provided adequate facilities for the School of Education and also made possible the opening of University High School in 1932. Jointly established by the university and the Columbia public schools, the high school fulfilled the need for practice teaching facilities for education majors. The University High School was closed in 1966. The building was named for Patterson Wardlaw, dean of the School of Education. Its auditorium was named for Gov. John Drayton, one of the founders of South Carolina College. Its gymnasium was named for George Foster Peabody, who established the Peabody Foundation. The sculpture in front of the building, the *Torchbearer*, was given to the university by the artist, Anna Hyatt Huntington.

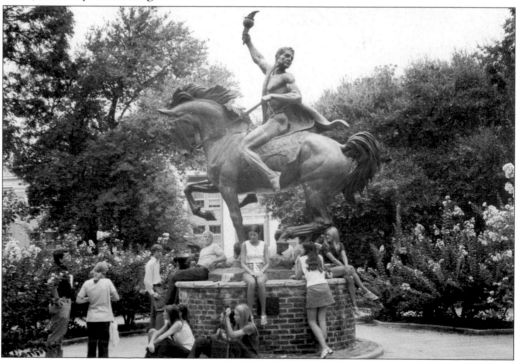

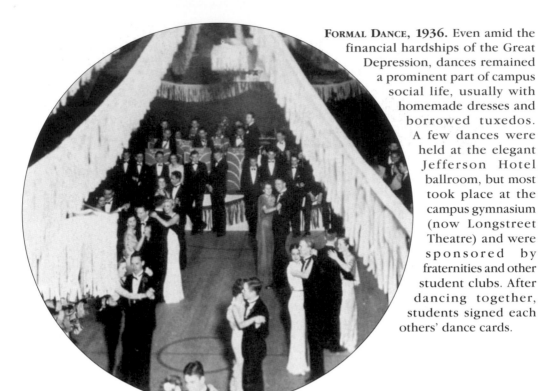

FORMAL DANCE, 1936. Even amid the financial hardships of the Great Depression, dances remained a prominent part of campus social life, usually with homemade dresses and borrowed tuxedos. A few dances were held at the elegant Jefferson Hotel ballroom, but most took place at the campus gymnasium (now Longstreet Theatre) and were sponsored by fraternities and other student clubs. After dancing together, students signed each others' dance cards.

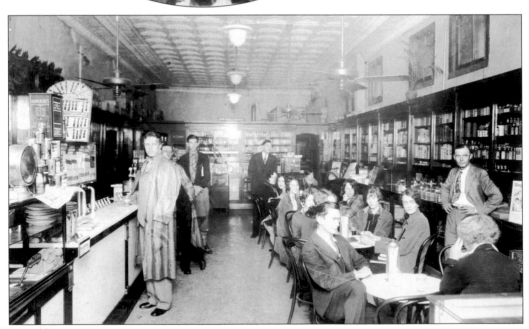

BURNETT'S DRUGSTORE, C. 1930. Other than dances, social activities in the 1930s were simple. Few students had cars, so many activities took place within walking distance of campus. Student went to the movie theaters on Main Street, shared a milkshake or a Coke at Burnett's drugstore, or went bowling. On campus, students had picnics, played piano in the women's dorm lounge, or sat on the Horseshoe benches, talking and holding hands.

COED FOLLIES

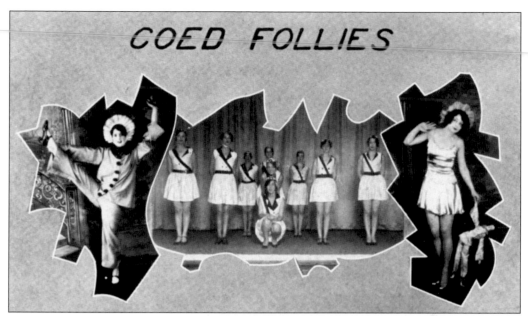

COED FOLLIES, C. 1930. A group of female students raised some eyebrows when they formed a dance and tap group called the University Coed Follies in 1929. After USC president Davidson M. Douglas began receiving complaints about the group from concerned citizens, the group agreed to drop "university" from their name. However, the majority of the public response was positive, and the Coed Follies performed across the state into the early 1930s.

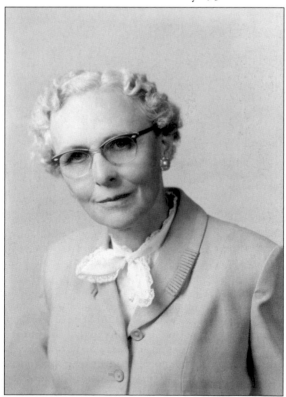

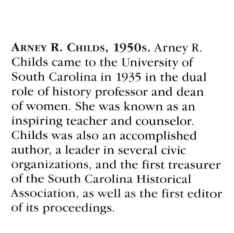

ARNEY R. CHILDS, 1950s. Arney R. Childs came to the University of South Carolina in 1935 in the dual role of history professor and dean of women. She was known as an inspiring teacher and counselor. Childs was also an accomplished author, a leader in several civic organizations, and the first treasurer of the South Carolina Historical Association, as well as the first editor of its proceedings.

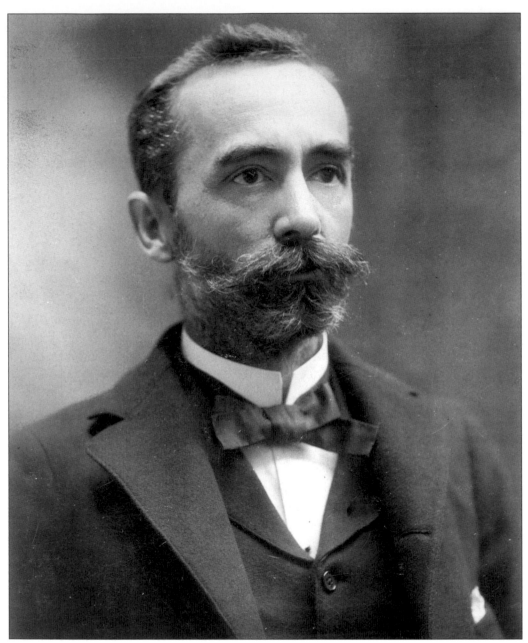

WILLIAM B. BURNEY, *C.* **1890.** Chemistry professor William B. Burney holds the record for the longest-serving faculty member at Carolina: 51 years. Burney pursued his graduate studies at some of the finest universities, including the Sorbonne in Paris, the University of Heidelberg, and Johns Hopkins University. After joining Carolina in 1880, he served as the school's only chemistry professor for many years and remained with the university during some of its most difficult years. He also served as dean of the initial and short-lived attempt at a College of Pharmacy from 1888 to 1891. Burney was known as an inspiring and caring teacher and developed the chemistry department into one of the finest in the South. He taught until his death in 1931. One of the first two "Honeycomb" dormitories built in 1958 was named for him; it was torn down in 1996.

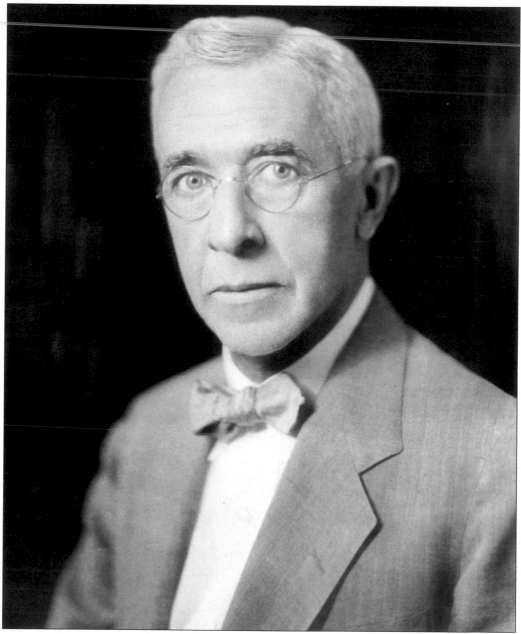

LEONARD T. BAKER, C. 1940. No one else in the university's history was called upon more often to lead the institution through difficult times than Leonard T. Baker. After joining the university as professor of education in 1906, Baker quickly rose to the position of dean of the university in 1914. Baker was called upon to serve as acting president of the university on three different occasions: 1926 to 1927, 1931 to 1932, and 1944 to 1945—each time after the death of the USC president. Baker was named president of the university in 1932 and guided the school through the hardships of the Great Depression. He stepped down as president in 1936 to become vice president and dean of the faculty. Upon his retirement in 1946, he became Carolina's first president emeritus. One of the first two Honeycomb dormitories built in 1958 was named for Baker; it was torn down in 1996.

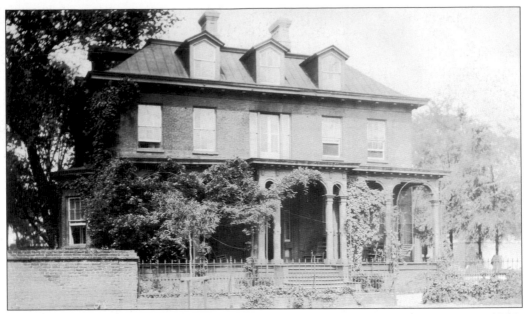

FLINN HALL ON ITS ORIGINAL SITE, 1920S (TOP), AND WORLD WAR MEMORIAL BUILDING, *C.* 1950.
Constructed in 1860, Flinn Hall was a faculty residence at the corner of Sumter and Pendleton
Streets. In 1910, it was named for Prof. William Flinn, who had lived in the house. It served
as the headquarters for the YMCA for many years. The World War Memorial Building was
constructed in 1935 under the direction of the War Memorial Commission and the Historical
Commission of South Carolina. Dedicated to the men and women of South Carolina who
died in World War I, it was paid for by private subscription and a federal grant from the Public
Works Administration. University trustees granted permission to place the building on the
corner of Sumter and Pendleton Streets, which required moving Flinn Hall back around 50
yards to its present location.

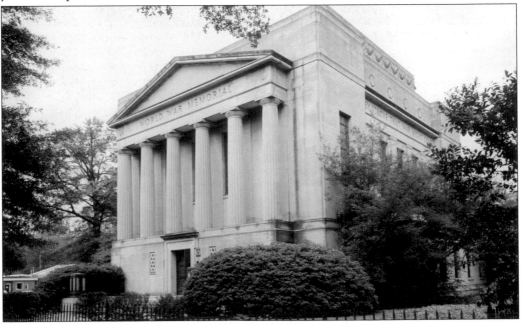

MELTON FIELD, C. 1935. Prior to the construction in 1934 of what is now Williams-Brice Stadium, university football games were played on Melton Field, now the location of the Russell House. After the Civil War, the field was used by Federal troops as drill and parade grounds. When the university was briefly reorganized as the South Carolina College of Agriculture and Mechanics from 1880 to 1882, the field was part of the school's 20-acre farm. When intercollegiate sports were approved by the university in the 1890s, the area was converted into a baseball field named for Prof. R. Means Davis and a football field named for William Davis Melton, who served as president of the institution from 1922 until his death in 1926. A brick and wrought-iron memorial gate was constructed at the field's entrance. When the gate was torn down to make way for the construction of the Russell House, a time capsule found inside one of the columns was given to the University Archives.

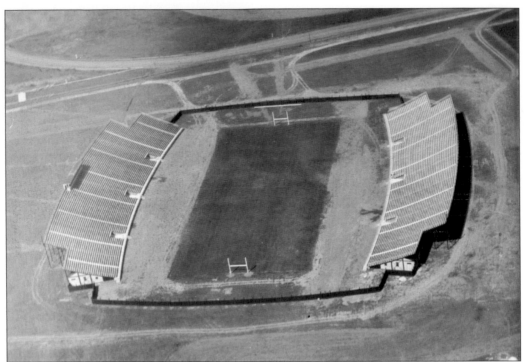

WILLIAMS-BRICE STADIUM, 1935 (TOP) AND 1972 (BOTTOM). Originally named Carolina Stadium, the structure was built in 1934 with federal funds from the Works Progress Administration and the title was transferred to the university by the city with the understanding that the university assume the remaining debt. The stadium has undergone several renovations and expansions since then, including the addition of the upper decks in 1972 and 1982. The renovations in the 1970s were made possible partly by a gift from the estate of Martha Williams Brice of Sumter. The stadium was dedicated as Williams-Brice Stadium in 1972 as a memorial to Mrs. Brice, her husband, Thomas H. Brice, and her parents, Mr. and Mrs. O. L. Williams.

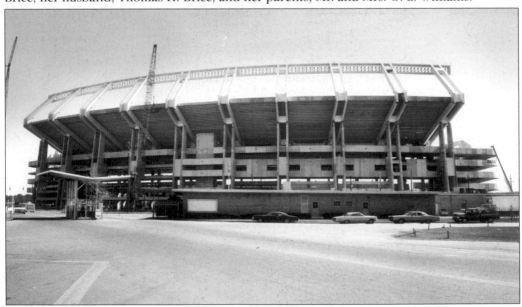

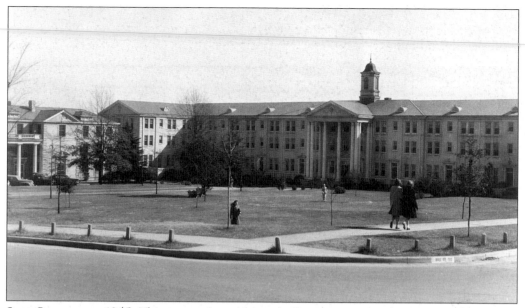

SIMS COLLEGE, c. 1945. This women's residence hall was constructed in 1939 as part of the New Deal building program that took place on campus in the late 1930s. It was named for South Carolina College alumnus James Marion Sims, a physician who was instrumental in establishing gynecology as a medical specialty.

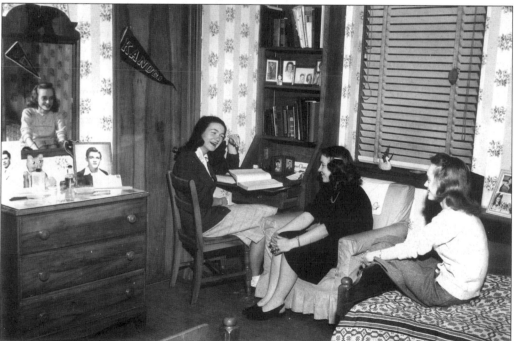

FEMALE STUDENTS IN DORM ROOM, c. 1940. Although all of the dormitories had stricter regulations in the 1930s and 1940s, female students were subjected to more stringent rules than their male counterparts. Special permission had to be obtained from the house mother to stay out after curfew, and any coed who violated that rule could face disciplinary action. Male students were not allowed past the lobby.

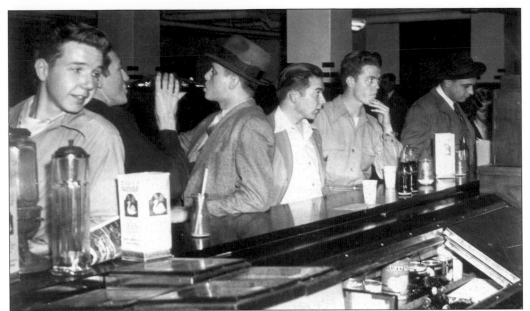

MAXCY COLLEGE CANTEEN, 1940S. Maxcy College was part of an extensive New Deal building program on the campus in the late 1930s. The residence hall was originally planned as a student union building and for many years had a popular student lounge in its basement. It was named for the Reverend Jonathan Maxcy, the first—and to date the longest serving—president of South Carolina College.

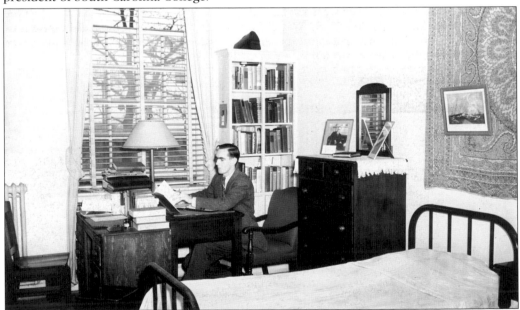

PRESTON COLLEGE DORM ROOM, *C.* 1940. This residence hall was built in 1939 as part of the extensive building program funded by the New Deal, which alleviated some of the university's financial strains brought on by the Great Depression. The building was named for William Campbell Preston, who served as South Carolina College president from 1845 to 1851. A great-nephew of Patrick Henry, Preston was considered an outstanding orator and a brilliant lawyer.

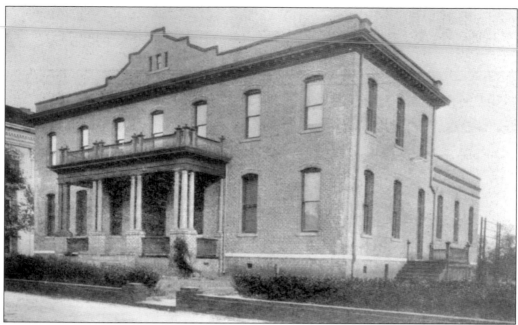

STEWARD'S HALL, 1930s. The name Steward's Hall was given to several buildings throughout the university's history. The above building at the corner of Sumter and Greene Streets was constructed in the early 1900s to replace the Steward's Hall that had been in use since 1848 and was in a severely deteriorated condition. Although students were no longer required to eat at Steward's Hall as they were in the early 1800s, it remained the main cafeteria for many years. Rationing during World War II forced the cafeteria to reduce the amount of meat served to students and restrict the amounts of sugar and coffee they could have. It was demolished in 1950 to make way for Sumwalt College.

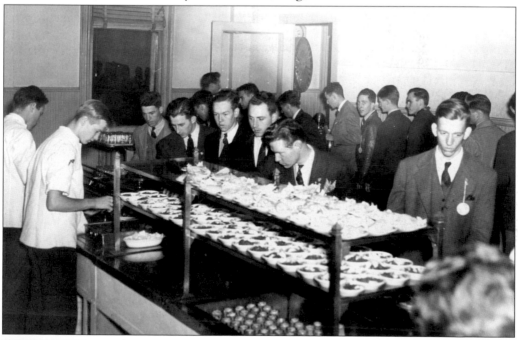

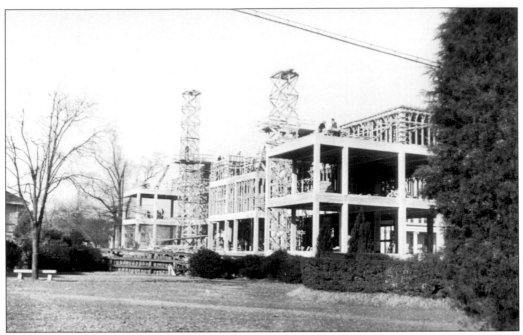

McKissick under Construction, 1939 (Top), and Ruins of the Old President's House, 1940 (Bottom). McKissick is the only 20th-century building on the Horseshoe. Constructed in 1940 to the rear of the original President's House, the building served as the university's main library until the opening of Thomas Cooper Library in 1976. McKissick was one of several buildings erected as part of the New Deal and was partially funded by the Works Progress Administration. It is named for James Rion McKissick, one of Carolina's most beloved presidents. It was rededicated as McKissick Museum in 1984, when the university's museum collections were placed under one roof.

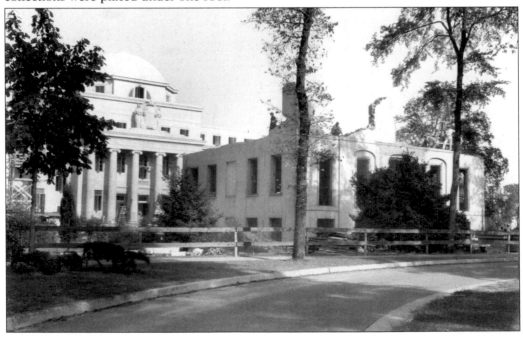

Three

WAR AND RENAISSANCE

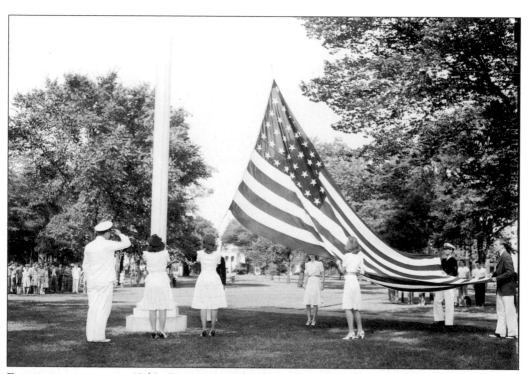

FLAGPOLE DEDICATION, 1942. During World War II, the university installed a flagpole on the Horseshoe so that the U.S. flag could be prominently displayed.

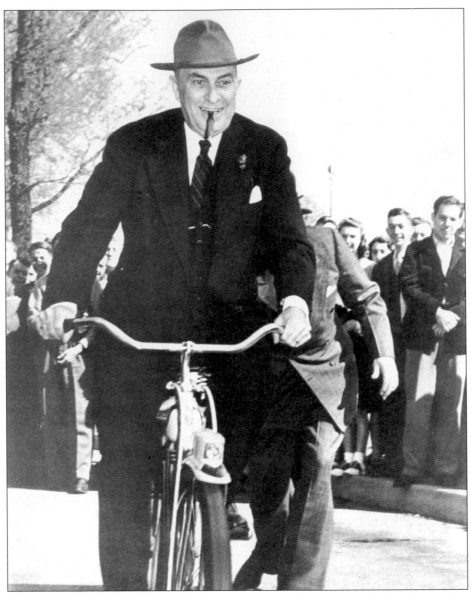

J. RION MCKISSICK ON HIS BICYCLE, 1940s. One of Carolina's most beloved presidents, J. Rion McKissick joined the university faculty in 1927 as dean of the School of Journalism. McKissick was a 1905 graduate of USC and had been among those students defending the campus during the 1902 Carolina-Clemson riot. He had also served as president of the alumni association and as a member of the board of trustees. McKissick was known for his ever-present cigar and slouch hat and for his impromptu speeches from the Maxcy Monument or atop a cafeteria table to address some infraction of discipline. He was often seen riding across campus on a bicycle given to him by his students. He served as president from 1936 to 1944, guiding the university through the close of the Great Depression and World War II. His sudden death on September 5, 1944, shocked the university community. The students petitioned to have their beloved president interred on campus. The trustees agreed, and McKissick was laid to rest in front of the South Caroliniana Library on the Horseshoe, the only person ever so honored.

Naval ROTC, *c.* 1943. With America's entry into World War II on December 7, 1941, the university came to resemble a naval base. In addition to the Naval Reserve Officer Training Corps unit established in 1940, Carolina was home to three U.S. Naval programs that more than made up for the drop in civilian enrollment. The school operated on a 12-month basis, and from 1943 until August 1945, no holidays other than Christmas were observed.

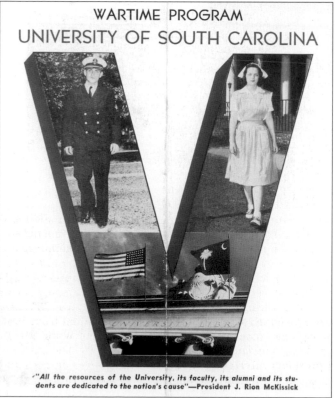

WARTIME PROGRAM
UNIVERSITY OF SOUTH CAROLINA

"All the resources of the University, its faculty, its alumni and its students are dedicated to the nation's cause"—President J. Rion McKissick

University Flyer, *c.* 1944. As it did during World War I, the university adjusted its curriculum to support the war effort for World War II. This included establishing a nursing degree program in 1944 and reassigning faculty members to teach navigation, mathematics, and communications in the navy's programs.

67

HOMECOMING QUEEN MARY KING, 1941. Mary King became the University of South Carolina's first homecoming queen in 1941. King remembered that homecoming as a wonderful day, but her heart was heavy. Her boyfriend, Edward K. Butler Jr., was being deployed overseas the following day. They married when he returned safely from his military service. Homecoming activities were suspended during the war, and the second queen was not elected until 1945.

NAVAL ROTC CORSETTES FEMALE DRILL TEAM, 1940s. As part of the Naval ROTC program, a drill platoon named the Corsairs was formed. A few years later, a mock female drill team named the Corsettes was formed.

FORMAL DANCE, 1940s. As in World War I, the German Club continued to hold formal dances during World War II. The Damas Club (another dance organization), the campus social cabinet, and the Greeks also held formals. The social cabinet dances were open to all students, but the club dances were mostly limited to members.

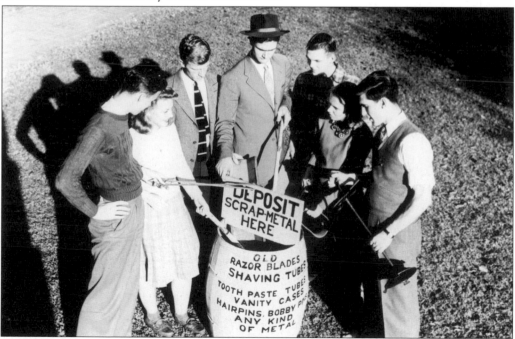

SCRAP METAL DRIVE, C. 1943. Students and faculty were not exempt from the rationing that took place to conserve food and supplies during the war. In this image, students are participating in a scrap metal drive, which collected used metal objects such as razor blades for recycling. Hairpins were in short supply due to the need for metal in the defense industries, so female students wore their hair in the "defense haircut," which did not require the use of pins.

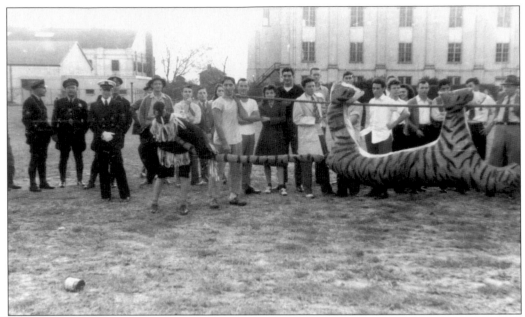

TIGER BURN, 1940s. Although the gamecock was adopted as the university mascot around 1902, there was no official costumed mascot until the 1970s. As a result, a variety of costumes were used over the years, like the one above.

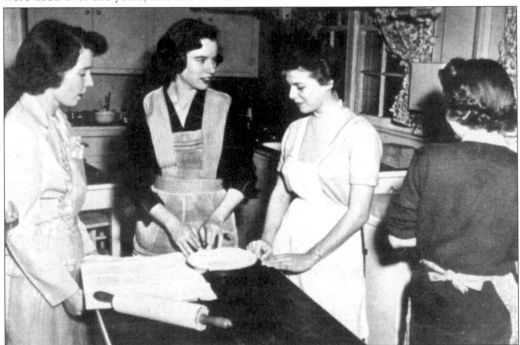

HOME ECONOMICS CLASS, c. 1945. The university established a department for homemaking in 1944. In the 1940s and 1950s, female students made up over one-third of the student body and gravitated toward the traditional majors like education and journalism. Only a handful enrolled in engineering and law. By the 1970s, however, women were moving into the traditionally male programs; since 1981, women make up the majority of the student body.

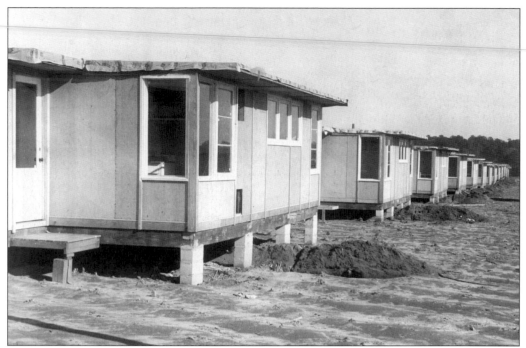

CAROVETS APARTMENTS, c. 1950. With the war's end in 1945, Carolina had to adjust to peacetime and the tremendous influx of veterans enrolling through the G.I. Bill. The number of students in 1946 was twice that of 1940, and more than one-half were veterans. Physical facilities, however, were inadequate to meet the increased enrollment, and the institution had to rely on surplus prefabricated government buildings. Among these were the Carovet Apartments, housing units provided for married veterans and their families. The apartments were located on Bull Street near the South Carolina State Hospital, and the university also provided a playground, clubhouse, and child-care services. The buildings were gradually torn down from the late 1950s into the early 1960s.

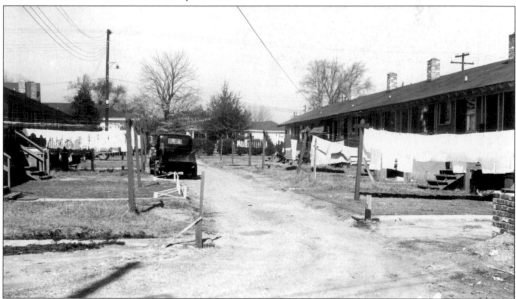

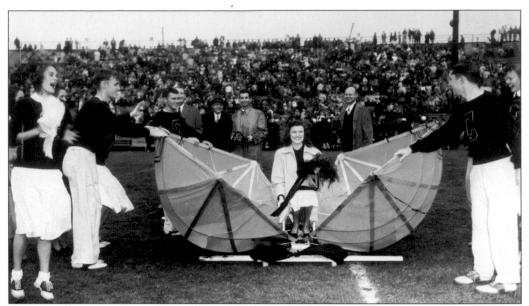

HOMECOMING QUEEN JACKIE JOHNSON, 1948. The identity of the 1948 Homecoming Queen was kept a secret until halftime. A giant football was carried onto the field, which opened to reveal Jackie Johnson. The homecoming queen tradition continued until 1991, when the position was abolished due to controversy over the election process. It was reinstated with the addition of a homecoming king in 1996.

FRESHMEN RECEIVING BEANIES, c. 1940. From the late 1890s until the 1960s, all male and female freshmen at Carolina were required to wear beanies to identify them as first-year students. Freshmen were also referred to as "rats," so the beanies became known as "rat caps." In the late 1940s and 1950s, many war veterans attending Carolina refused to submit to the traditional hazing of freshmen.

HAVILAH BABCOCK, 1950s. English professor Havilah Babcock was one of the most beloved professors in USC history, known for his wit, anecdotes, and love of the English language. His vocabulary-building course "I Want a Word" was always full. His love of hunting and fishing was also well known, and he authored numerous essays and several books on the subject. He taught English at Carolina from 1927 until his retirement in 1964.

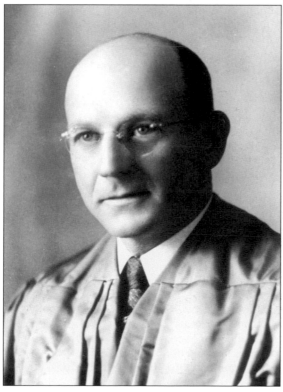

SOLOMON BLATT SR., c. 1950. Due to the crowded conditions of the campus's location within the city, university trustee and South Carolina speaker of the house Solomon Blatt Sr. proposed a plan in 1949 that would move the university to a more spacious area outside of Columbia. Although the plan had the support of other trustees and state officials, the outcry from alumni and students, as well as a lack of money, quickly killed the idea.

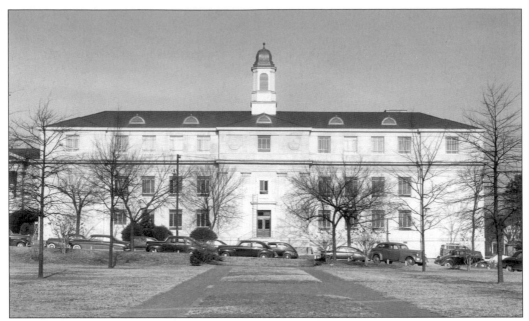

PETIGRU COLLEGE, 1950S. Petigru College was the first major construction project on campus since 1943. Shortages of materials, labor, and funding during and immediately after the war limited the university to the temporary fix of prefabricated war surplus buildings. Petigru was built in 1950 as the new law school and was named for James Petigru, a noted South Carolina attorney and former U.S. district attorney.

LECONTE COLLEGE, C. 1952. Built in 1952, this science building was named for brothers John and Joseph LeConte, who were among the renowned scientists of the 19th century. John LeConte began teaching physics at South Carolina College in 1856. Joseph LeConte arrived the same year to teach chemistry. The brothers left the school in 1869.

OSBORNE ADMINISTRATION BUILDING, c. 1980. This 1952 building was the first structure at Carolina built specifically to house the university's administrative offices. In 1973, the building was named in honor of longtime board of trustees member Rutledge L. Osborne. Osborne was a member of the board from 1947 until he resigned in 1975 at the age of 80. He served as board chairman from 1952 to 1970, longer than any individual in the university's history.

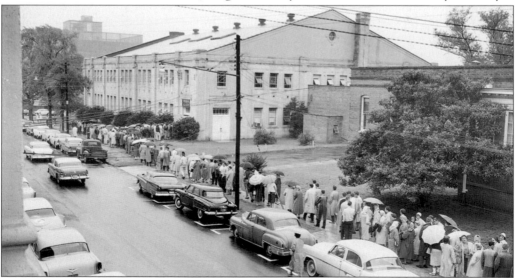

FRESHMEN WAITING FOR ORIENTATION, 1950s. Registration and freshman orientation meant long lines snaking across the Horseshoe and outside the old Field House. When the Carolina Coliseum was built, the long lines moved indoors. Online registration finally eliminated most of the lines at registration.

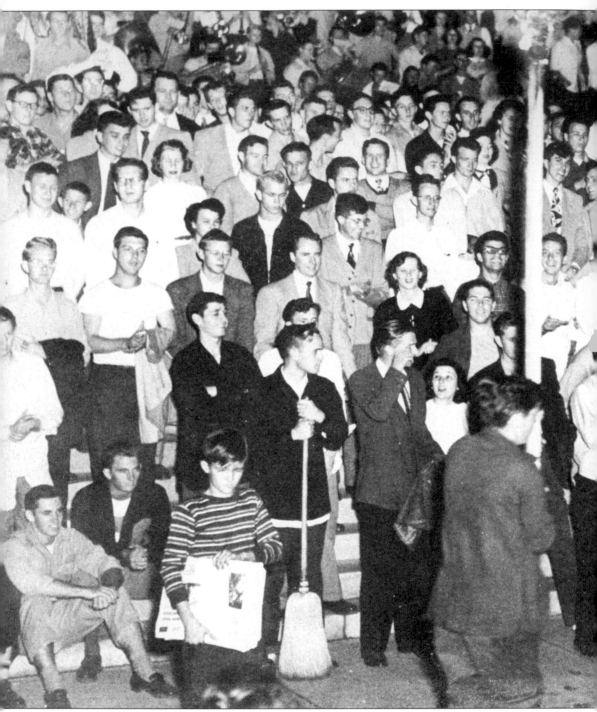

PEP RALLY AT THE SOUTH CAROLINA STATE HOUSE, 1950. Homecoming pep rallies were first held in the 1930s and occurred in a variety of forms over the years. Bonfires held on Davis and Melton Fields were popular during the 1940s. In 1950, no pep rally was scheduled, but one occurred anyway. The Carolina cheerleaders were meeting in the Field House with a small group of students and the university band to discuss new cheers. Other students followed

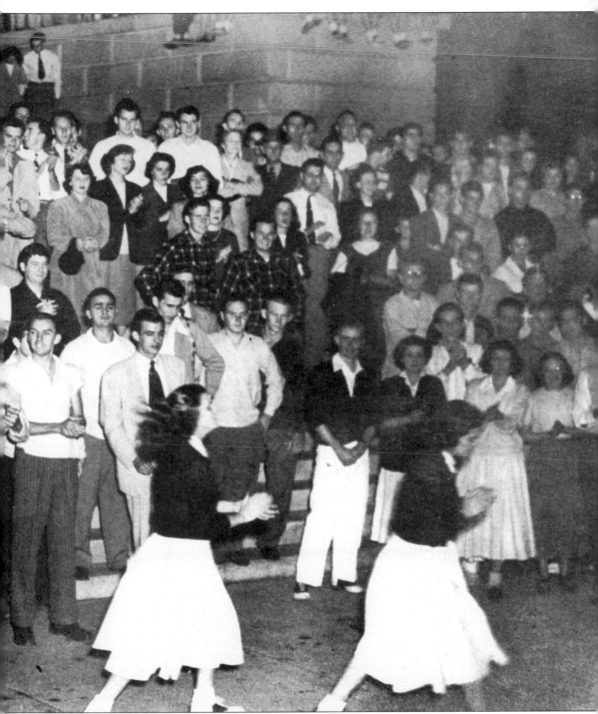

them in, and the crowd grew to approximately 1,500. The students and most of the band members then led an impromptu parade to the South Carolina State House and held a rally on the steps. Upon noticing the noise and torchlights, Gov. Strom Thurmond joined the assembly and made a few remarks, much to the delight of the students.

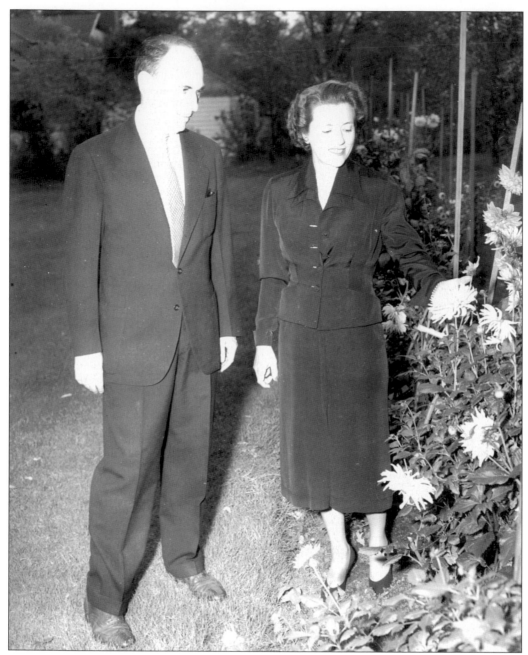

DONALD AND VIRGINIA RUSSELL, 1950s. Few individuals achieve the wide-ranging success and lengthy career that Donald S. Russell enjoyed. Russell held important positions in the Franklin D. Roosevelt administration during World War II, practiced law in South Carolina, and served as president of the University of South Carolina, governor, U.S. senator, and federal judge. He served as an appellate court judge until the time of his death, in 1998, on his 92nd birthday. At Carolina, Russell was the right man at the right time. Under Russell's leadership, the university experienced a kind of renaissance, with growth in its physical plant, a reorganization and strengthening of its academic programs, and a revitalization of the Carolina spirit after the postwar doldrums.

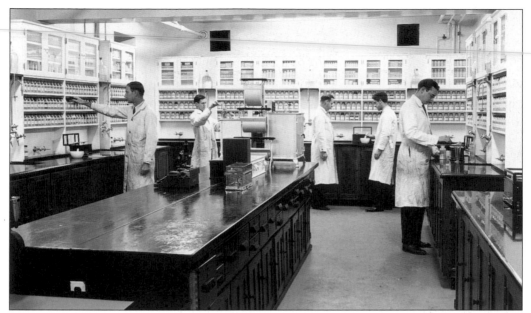

CHEMISTRY LABORATORY, C. 1950 (TOP), AND PHYSICS DEPARTMENT NEUTRON GENERATOR, 1950S (BOTTOM). Mindful of the cold war and American competition with the Soviets, President Russell put much of his energy into improving the basic sciences at USC, which had been suffering from inadequate facilities and a lack of properly trained faculty. Russell noted that South Carolina ranked poorly in the production of chemists and physicists. The physics department was drastically overhauled, and Russell recruited an outstanding faculty to beef up the program. Course offerings, facilities, and equipment were also upgraded; enrollment in physics courses more than doubled during Russell's administration.

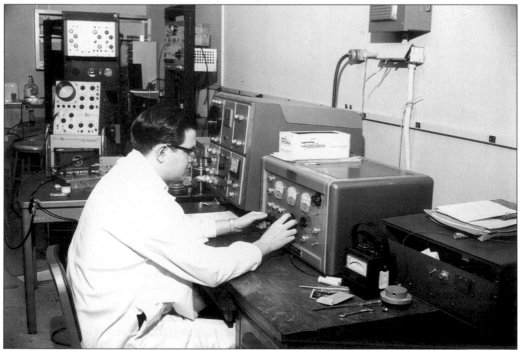

MAY DAY, 1950s. In addition to the homecoming queen and Miss Garnet and Black, students also elected a May queen each year. The May Day festivals were large and elaborate, with the May queen and court wearing elegant dresses.

TYPICAL FRESHMAN ATTIRE, 1950s. The university continued to have a dress code in the 1950s. Students were expected to dress neatly and conservatively for class.

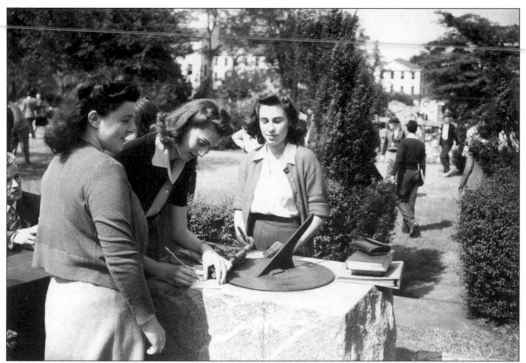

STUDENT ELECTIONS AT THE SUNDIAL, 1950S. Voting for student government elections used to be conducted at the Omicron Delta Kappa sundial near Currell College.

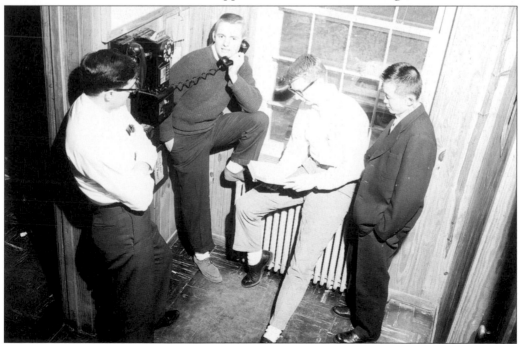

STUDENTS USING DORMITORY TELEPHONE, 1950S. Modern students may be shocked to learn that dorms did not always have telephone connections. Students in the 1950s had to share hall telephones.

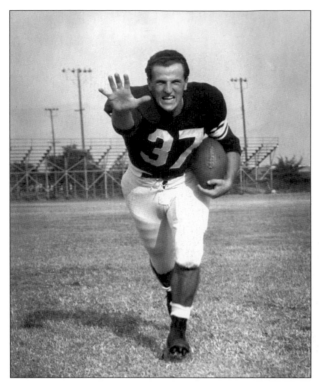

STEVE WADIAK, 1950. The 1950s gave Carolina several top athletes. One of the first superstars of Carolina football, running back Steve "the Cadillac" Wadiak was Southern Conference player of the year in 1950 and a top candidate for numerous All-America teams. Wadiak died tragically in a car accident in 1952, his senior year. In 1954, Frank Mincevich became USC's first All-American football player, and in 1957, Grady Wallace became the first All-American Gamecock basketball player.

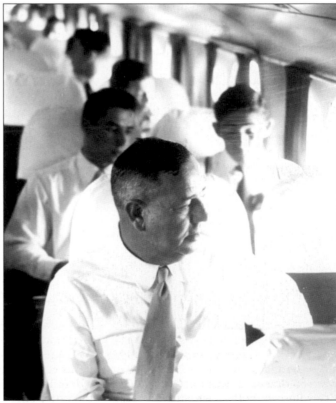

REX ENRIGHT AND TEAM TRAVELING TO GAME, 1950S. Rex Enright served as head football coach from 1938 to 1956, longer than anyone else in Carolina history. He also served as athletic director from 1938 until his death.

DONALD RUSSELL (RIGHT) AND JOHN F. KENNEDY, 1957. President Russell used his contacts with the State Department to bring nationally prominent figures to the campus, including a young rising star in the Democratic Party who gave the 1957 USC commencement address—Sen. John F. Kennedy of Massachusetts.

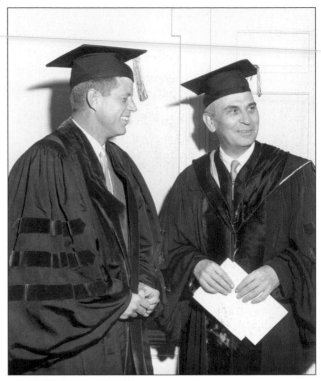

RUSSELL HOUSE CONSTRUCTION, 1955. The Russell House was constructed in 1955 as a student union building and was expanded in 1958, 1967, and 1976. The structure's modern design set a new standard for architectural style on campus but generated complaints that the change was too drastic. It was named for USC president Donald S. Russell and his wife, Virginia Utsey Russell, both of whom are alumni of the university.

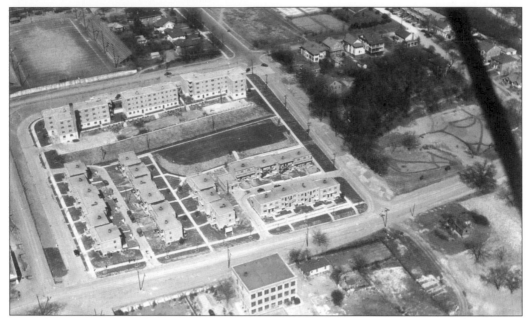

AERIAL VIEW OF UNIVERSITY TERRACE, 1950S. During the university's physical expansion in the 1950s, it purchased areas designated as slum housing, including property in the Wheeler Hill community and the University Terrace housing project at the corner of Blossom and Bull Streets. The complex provided on-campus housing for married students until its demolition in 1995 to make way for a parking garage.

CALLCOTT SOCIAL SCIENCES CENTER, C. 1960. Callcott was built in 1955 as the new home of the School of Business Administration. It was named Callcott after the business school moved into a much larger building in 1973. Wilfrid Hardy Callcott served the university as faculty and administrator for 45 years. In addition to teaching history, he served as the dean of the graduate school, dean of the faculty, and dean of the university.

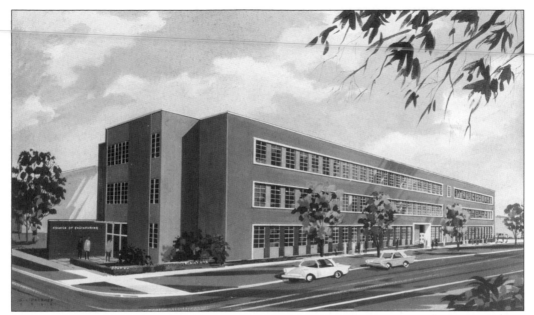

ARTIST'S DRAWING OF SUMWALT COLLEGE, 1955. Sumwalt College was built in 1955 (with an addition in 1959) to house all of the engineering departments in one building. It was the first building to use a modern design that broke with the traditional look of the old campus. It was named for engineering dean Robert L. Sumwalt, who served as acting president from 1957 to 1959 and president from 1959 to 1962.

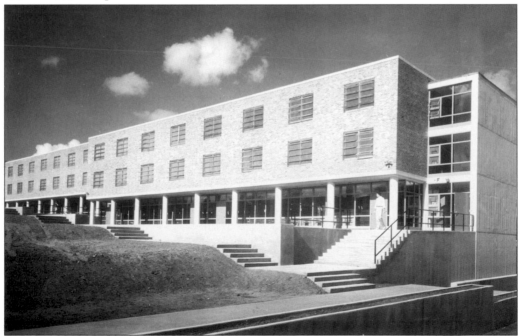

McBryde Quadrangle, c. 1955. Also referred to as Fraternity Row, McBryde Quadrangle was constructed in 1955 as fraternity housing. The complex was named for John M. McBryde, a Carolina alumnus who served as president of the institution from 1882 to 1883, chairman of the faculty from 1883 to 1888, and president again from 1888 to 1891.

RICHARD WALKER, C. 1960. One of the most noted scholars of the university's modern era, Richard Walker joined the faculty in 1957. USC president Donald S. Russell personally recruited the Yale graduate and faculty member as part of his efforts to broaden the university's political coursework from just domestic policies into international problems and foreign policy. Walker was an Asian studies specialist at a time when most U.S. foreign policymakers were focused on Europe. He established the department of international studies in 1957, which developed into the Institute of International Studies in 1961. The institute was renamed in his honor in 1996. The program Walker developed was one of the first international studies programs in the nation that incorporated world studies into the undergraduate curriculum. The institute regularly brought in notable guest lecturers from both government and academia as well as leading foreign-policy thinkers. In 1981, Pres. Ronald Reagan named Walker U.S. ambassador to South Korea; he served in that capacity until 1986, when he returned to the university.

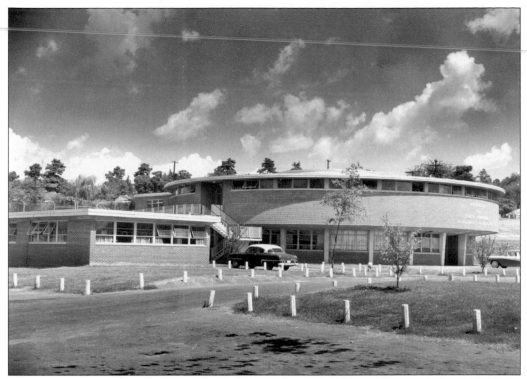

ROUNDHOUSE (REX ENRIGHT ATHLETIC CENTER), C. 1960. Better known as the "Roundhouse" due to its unusual shape, this building was constructed in 1956 to house the offices of the Department of Athletics. It was named for longtime coach and athletic director Rex Enright.

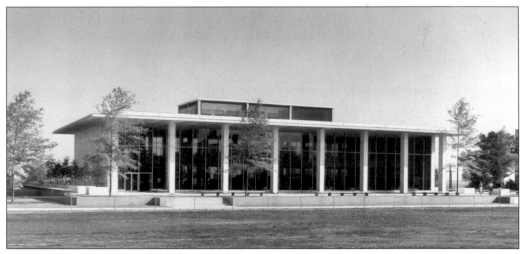

THOMAS COOPER LIBRARY, 1960. The original section of Thomas Cooper Library was constructed as an undergraduate library in 1959. Rapidly increasing enrollment in the 1960s and 1970s led to the construction of a large, partially underground addition in 1976 that transformed the building into the main library on campus. It was then named for Thomas Cooper, South Carolina College's controversial second president.

CHESTER TRAVELSTEAD, C. 1955. Chester Travelstead was at the center of a dispute over desegregation and free speech at the university. He had joined USC in 1953 as the dean of education as part of that school's reorganization. Travelstead believed that South Carolina's efforts to fight desegregation was stifling the ability of faculty members to openly and critically discuss racial segregation. In May 1955, Travelstead sent a letter to Gov. George Bell Timmerman in which he challenged Timmerman's position on desegregation. Timmerman attempted to have the dean fired, stating that he was a bad influence on the university's students. President Russell refused to fire him, but another controversy developed later that year when Travelstead gave a public lecture to some summer-school students in which he attacked racial segregation at length. Two weeks after his speech, the board of trustees fired Travelstead, stating that it was not in the university's best interest to employ him.

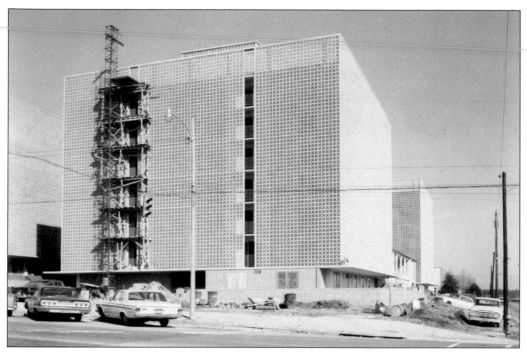

HONEYCOMBS, *C.* 1962. Also known as the Towers, the Honeycombs were constructed in 1958, 1962, and 1965 as student residence halls. The name "Honeycombs" refers to the veil block pattern that covers the exteriors. The buildings' design received immediate criticism, including a comment that they resembled air-conditioning units. The two oldest buildings were demolished in 1996 to make way for the Graduate Science Research Center. The remaining buildings are slated for destruction in the summer of 2006. An honors residence hall is planned for the site.

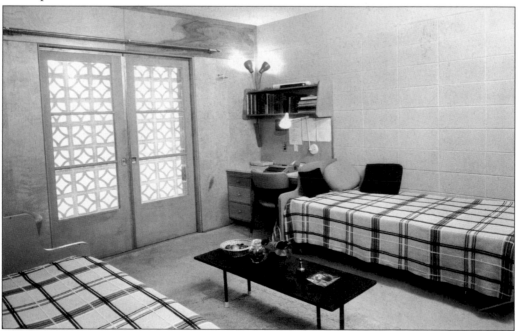

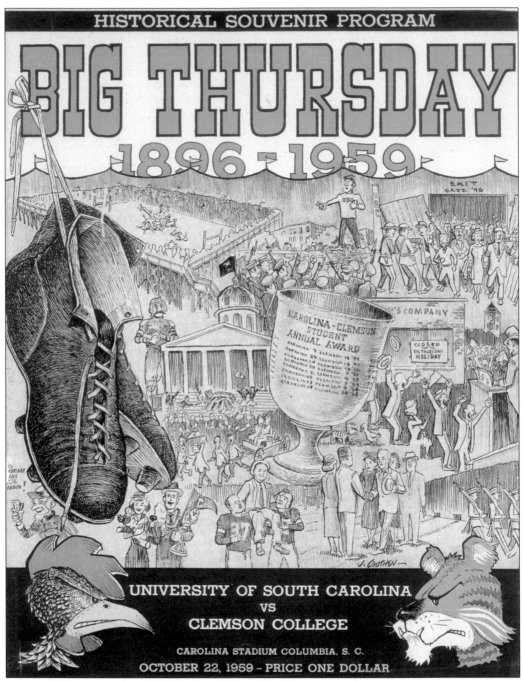

FINAL BIG THURSDAY PROGRAM, 1959. The final Big Thursday game was played on October 22, 1959. For decades, the annual Carolina-Clemson football game had been held at the state fairgrounds in Columbia, which essentially gave Carolina the home field advantage every year. Clemson coach Frank Howard had tried for years to change the arrangement. He and Carolina coach Rex Enright finally negotiated the end of tradition, to the dismay of many Carolina and Clemson fans. Beginning in 1960, the teams alternated playing at each other's home fields. Efforts have been made periodically to revive the tradition.

Four

A MODERN UNIVERSITY

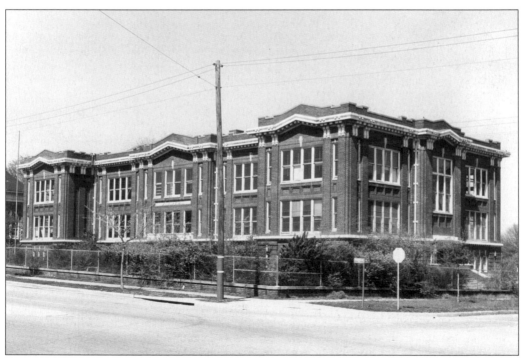

McMaster College, c. 1960. Constructed in 1911, McMaster College originally was a public grammar school. It was named for Col. F. W. McMaster, chairman of the first board of school commissioners. The university acquired the property in 1960 and renovated it for the School of Music. A recital hall adjoining McMaster was named for Arthur Fraser, who was head of the music department from 1963 to 1972.

OLD COKER COLLEGE, 1962 (TOP), AND COKER LIFE SCIENCES BUILDING, C. 1976 (BOTTOM). Constructed in 1962, the building at the corner of Sumter and Greene Streets was originally the home of the College of Pharmacy and the Department of Biology. It was named Coker College in honor of David R. Coker, one of the university's most outstanding alumni and a former member of the board of trustees. Coker originated varieties of staple cotton that are widely cultivated in the United States and other countries and established Coker's Pedigreed Seed Company in Hartsville. He was widely acclaimed as the South's foremost agricultural statesman. When the College of Pharmacy and the Department of Biology moved into the newer Biological Sciences Center (1976), the original building was renamed the Health Sciences Building and the Coker name transferred to the new building.

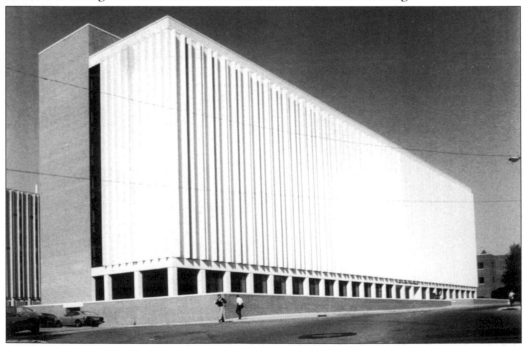

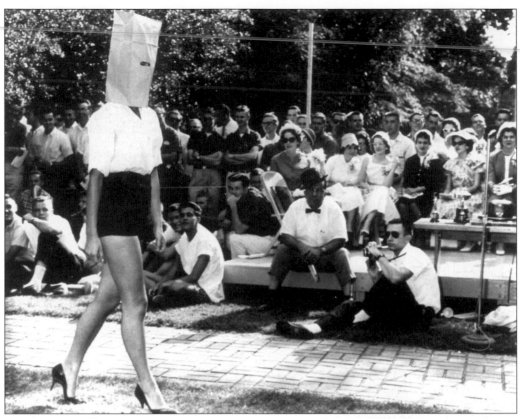

MISS VENUS, 1960S, AND PRESIDENT SUMWALT AS JUDGE, C. 1960. The Miss Venus Pageant was part of the Greek-sponsored Derby Day festivities. The pageant was held from the 1940s to the early 1970s. The coed contestants, who were judged by Sigma Nu brothers and university administrators, wore tight blouses, short shorts and high heels, and paraded in front of the judges with paper bags over their heads so that they could be judged for their "other attributes." The pageant was discontinued sometime in the early 1970s.

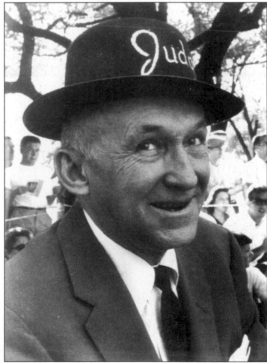

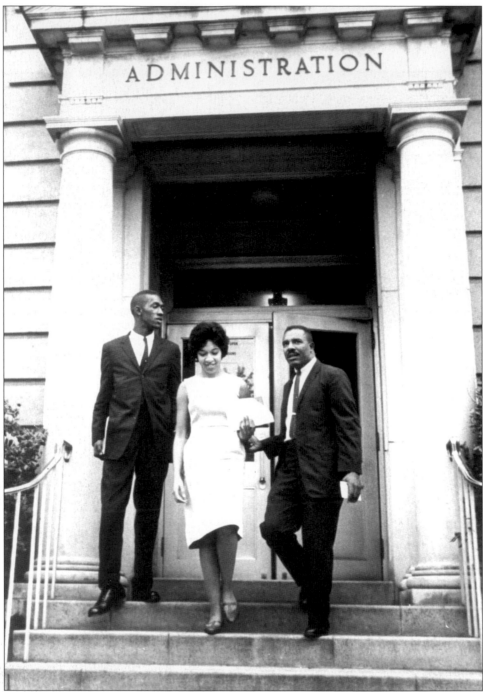

ROBERT ANDERSON (LEFT), HENRI MONTEITH (CENTER), AND JAMES SOLOMON (RIGHT), 1963. In the fall of 1963, the university was integrated for the second time in its history—this time by court order. Although about 200 USC students burned a cross on campus at an anti-integration rally in May 1963, the violence that accompanied the integration of some other Southern universities did not occur at Carolina, and James Solomon, Henri Monteith, and Robert Anderson became the first African American students to enroll since Reconstruction.

Tea Dance with Gamecock Orchestra, *c.* **1965.** In 1962, the tea dance was established as a Carolina homecoming tradition. The alumni association took over responsibility for the dance, and Buster Spann and the Original Gamecock Orchestra provided the music. This was a reunion of former students who had belonged to USC's Gamecock Orchestra in 1930. The 1962 reunion proved so popular that the group continued to play at every homecoming until 1988.

Student Working on a Homecoming Float, 1964. Parades were dropped from homecoming activities during World War II and were not resurrected until 1953. Although they waned in popularity at the end of the 1950s, a restructuring of homecoming's look in the early 1960s made parades a major part of the festivities.

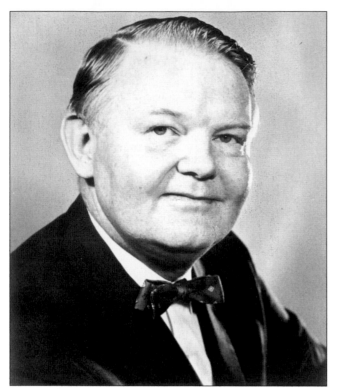

THOMAS F. JONES, c. 1970. One of the longest-serving presidents at USC, Thomas Jones oversaw a period of tremendous growth at the university. Jones became president in 1962. When he left in 1974, enrollment had more than tripled, and 29 new buildings had been added to the campus. Jones also oversaw the desegregation of the university and dealt with the student activism of the 1970s.

ROBERT L. SUMWALT JR. (LEFT), HAROLD BRUNTON (CENTER), AND PRESIDENT JONES, 1967. Carolina faced a student housing crisis in the 1960s due to rapidly increasing enrollment. This prompted a building boom in the 1960s and early 1970s, under the direction of Harold Brunton, dean of operations. In this image, Brunton, Pres. Thomas F. Jones, and Robert L. Sumwalt Jr. celebrate the completion of Capstone House.

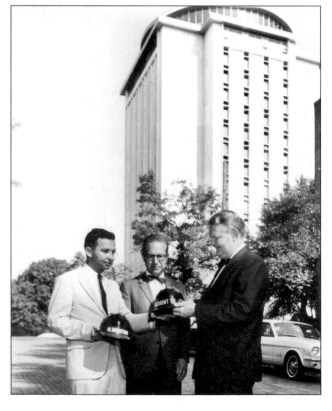

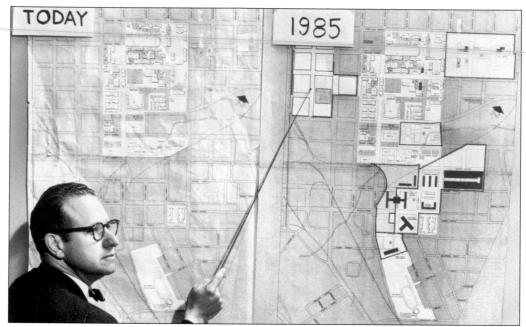

UNVEILING OF LONG-RANGE DEVELOPMENT PLAN, 1965. The university's rapid expansion required the development of a long-range development plan, which Harold Brunton presented to the public in 1965. The plan mapped out campus expansion to the east, west, and south of the university over a period of 20 years. The master plan has been revised several times over the years.

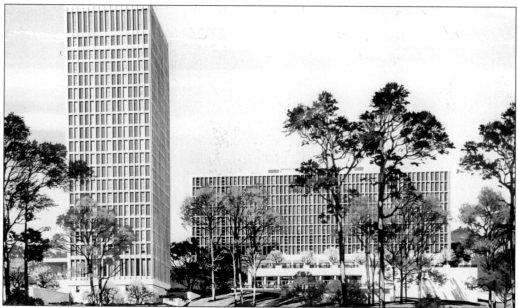

PATTERSON HALL AND SOUTH TOWER, 1965. This artist's drawing of women's dormitories Patterson Hall and South Tower shows the view from Blossom Street with the A. C. Moore Gardens in the rear of the buildings. Originally called South Building, Patterson Hall was constructed in 1962 and named for longtime university administrator and president William H. Patterson. South Tower was constructed in 1965.

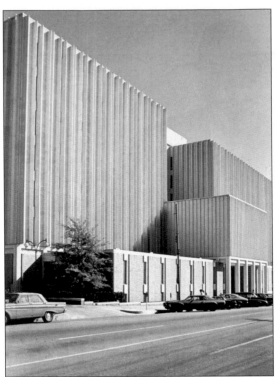

JONES PHYSICAL SCIENCES BUILDING, 1967. Constructed in 1967, this facility was designed specifically for the chemistry and physics departments. The modern architecture facility represented the university's development into a science research center. It was named for USC president Thomas F. Jones, who oversaw a period of tremendous growth in enrollment, academic programs, and the physical campus.

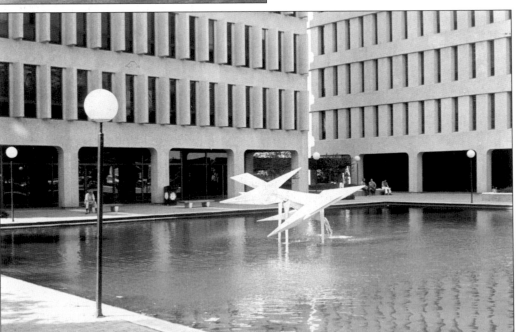

WELSH HUMANITIES COMPLEX, c. 1970. In 1968, the university constructed a two-building complex to provide office and classroom space for humanities departments. The complex originally included a reflecting pool with a sculpture; a restaurant was constructed on the site in 2006. The complex was named for English professor and vice president of instruction John R. Welsh.

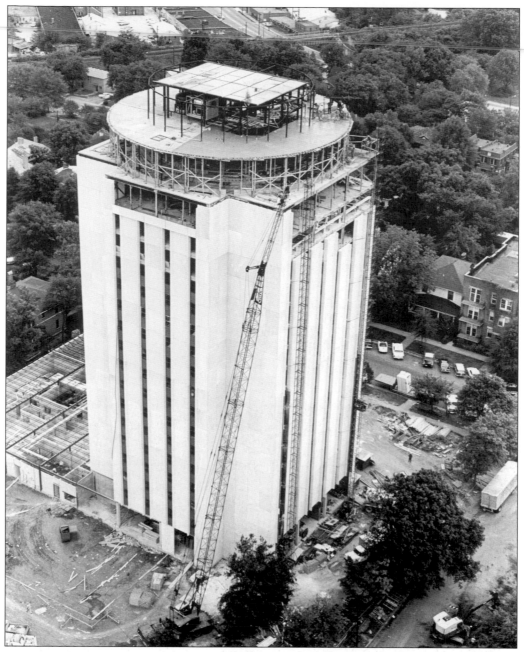

CAPSTONE HOUSE UNDER CONSTRUCTION, 1967. The university's first honors residence hall was built in 1967 and topped with a rotating dining facility; the rotating platform and mechanism were acquired from an exhibit at the New York World's Fair and were given by South Carolina manufacturer Robert G. Wilson. The building was named Capstone because it was the crowning point of the East Campus. However, the name generated a piece of USC folklore when a tongue-in-cheek editorial claimed it was named for Commodore Epaminondas J. Capstone, a Carolina graduate and Civil War hero. The fictitious story appeared on a picture postcard of Capstone.

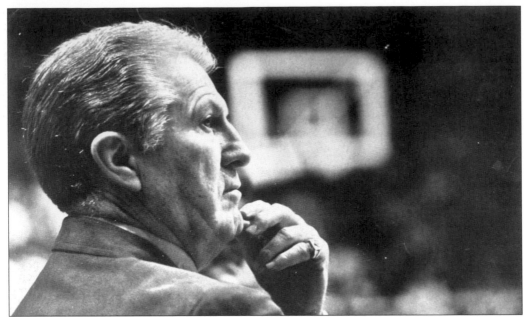

FRANK McGUIRE, 1970s. Carolina fans were ecstatic with the hiring of basketball coach Frank McGuire in 1964. By 1968, the Gamecock basketball team was a national power, filling the Carolina Coliseum with fans and regularly participating in post-season tournaments. They remained national championship contenders on into the 1970s. McGuire later clashed with USC president James Holderman and left USC in 1980.

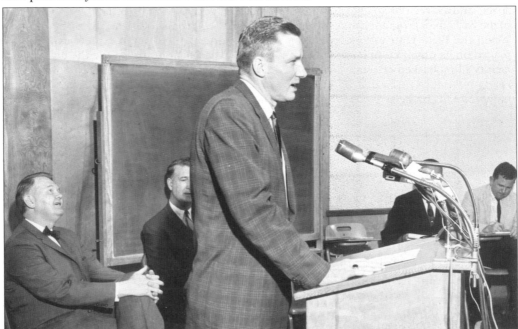

PAUL DIETZEL, c. 1966. The late 1960s also saw success for the football team with the hiring of Paul Dietzel as football coach and athletic director. Although Dietzel's first three seasons were losing ones, in 1969, the Gamecocks had their first winning season since 1958 and were the Atlantic Coast Conference champions. Dietzel left USC in 1975.

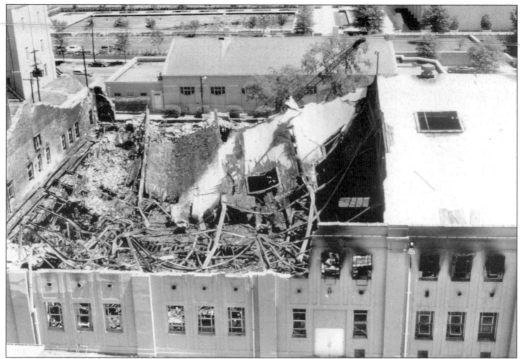

OLD FIELD HOUSE AFTER FIRE (TOP) AND THE CAROLINA COLISEUM (BOTTOM), 1969. The Carolina Coliseum was built in 1968 to provide a first-rate facility for intercollegiate athletics, academic space, and a large versatile arena for entertainment events in the Columbia area. The success of the basketball program had demonstrated how inadequate the old Field House had become. When the Field House burned during the coliseum's construction, a new urgency was placed on its timely completion. The arena was finished only hours before the tip-off of the facility's first basketball game. The coliseum also provided a new venue for commencement ceremonies, which had been held on the Horseshoe. In 1977, the arena was named in honor of famed USC basketball coach Frank McGuire.

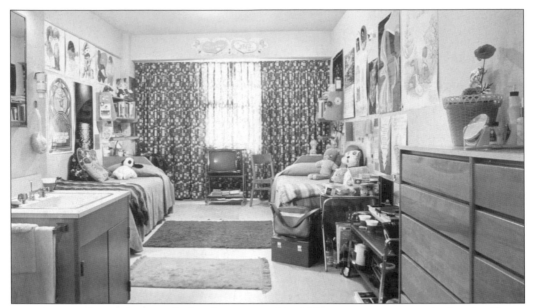

BATES HOUSE DORM ROOM, 1970s. Constructed in 1969, Bates House marked a significant departure from the usual residence hall design. The intent was to move away from the institutional approach and personalize students' living quarters through a variety of room arrangements and colors. Bates West, completed in 1974, was the university's first coed residence hall. They are named for alumnus Jeff B. Bates, who served as South Carolina state treasurer from 1940 until his death in 1966.

STUDENTS IN ELEVATOR, 1970s. In the 1960s and 1970s, fewer and fewer students followed the university's dress code, as evidenced by this image. In the earlier part of the century, students would have faced disciplinary action for appearing in public without a shirt or with hair curlers. The dress code was abandoned in the 1970s, and dormitory rules were also relaxed.

GENERAL WESTMORELAND RECEIVES AN HONORARY DEGREE, 1967. The 1967 visit of Gen. William C. Westmoreland sparked protests among some students and faculty members. Westmoreland, a Spartanburg native and commander of U.S. troops in Vietnam, was at USC to receive an honorary degree. During the ceremony, assistant professor of chemistry Thomas Tidwell held up an anti-war sign and shouted, "I protest: Doctor of War!"

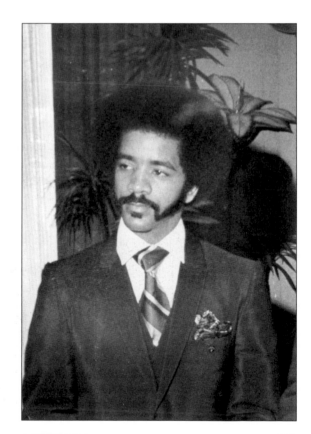

HARRY WALKER, 1971. In the years following the 1963 desegregation of the university, African American enrollment rose slowly. However, in 1971, Harry Walker became the first black student body president.

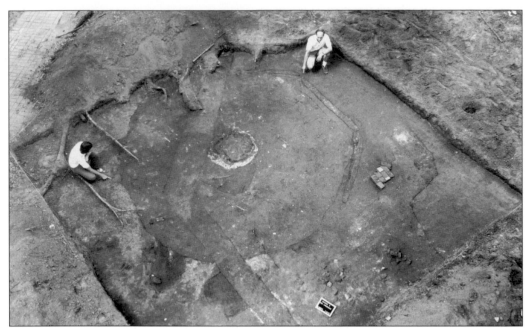

EXCAVATION OF HORSESHOE, *C.* 1973. In the mid-1970s, the university undertook an extensive restoration project for the historic Horseshoe. The earliest impetus for the project occurred in 1972, when a shower stall in one of the men's residence halls on the Horseshoe fell through a rotted floor (fortunately it was unoccupied at the time). The project started with an archaeological dig in 1973 that uncovered the old college wells. Over a period of 10 years, and at an expense of over $10 million, the Horseshoe's buildings were restored as much as possible to their appearance prior to 1860. Bricks from part of the old Booker T. Washington High School were used to replace the asphalt of the Horseshoe drive.

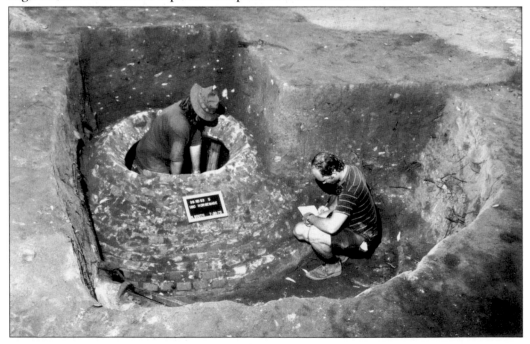

AFTERMATH OF STUDENT TAKEOVER IN OSBORNE, 1970 (TOP), AND NATIONAL GUARD TROOPS DEPLOY TEAR GAS, 1970 (BOTTOM). In May 1970, USC experienced a brief period of violent student unrest, as did other universities during the Vietnam War era. On May 7, following a rally protesting the shooting of students at Kent State University by National Guardsmen, a group of students locked the doors and occupied the Russell House student union building for about five hours. Then on May 11, students briefly took over and trashed part of the Osborne Administration Building. That evening, armed National Guardsmen used tear gas to clear students from the Horseshoe area of campus and restore order.

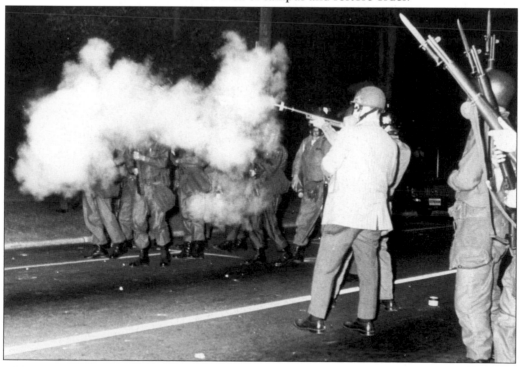

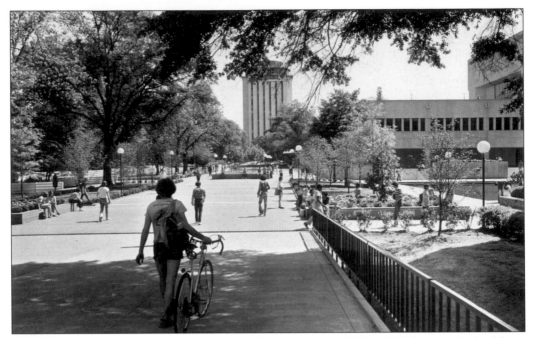

STUDENTS CROSSING PICKENS STREET BRIDGE, 1970s. Between 1967 and 1976, six major buildings were constructed on the East Campus. The tremendous increase in the number of students crossing Pickens Street prompted the university to construct a pedestrian bridge.

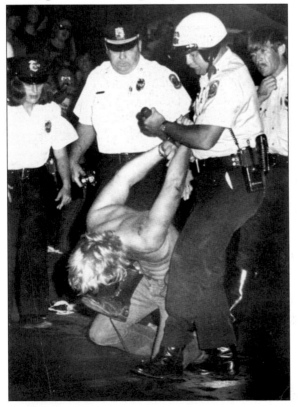

STUDENT ARRESTED AT GREENE STREET PROTEST, 1975. The construction of the Russell House on Greene Street increased the amount of student foot traffic crossing the busy street. The issue came to a head in the 1970s, when students began actively pressing for the closure of the street where it crossed the campus. Eighteen students were arrested at a demonstration in 1975. Columbia City Council finally agreed in 1977 to close it during certain hours on weekdays.

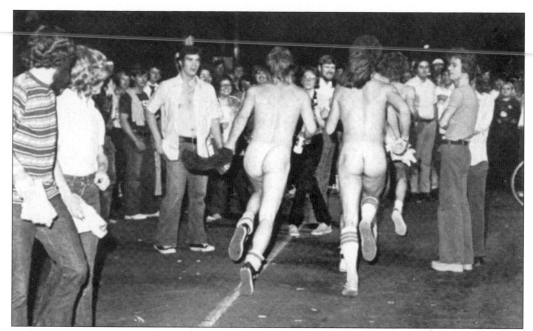

STUDENTS STREAKING UP GREENE STREET, 1974. In 1974, Carolina was hit with the latest college fad: streaking. A mass streak planned in March attracted a crowd of 5,000 onlookers and an ABC-TV news crew. At 10:00 p.m., 508 students ran up Greene Street toward Capstone. The wife of USC president Thomas Jones stated that the news coverage of the event was in good taste, but the bodies were not.

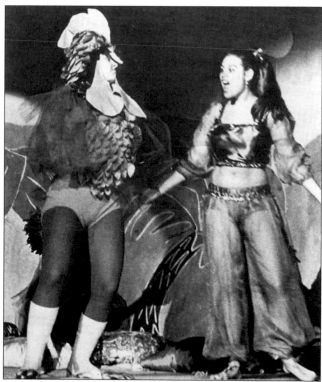

COCKFEST SKIT, 1973. The traditional homecoming pep rally was replaced with Carolina Capers, a student variety show, in 1962. Cockfest succeeded Carolina Capers in 1971. It features skit competitions by campus organizations, appearances by the football coach and team, and guest performers.

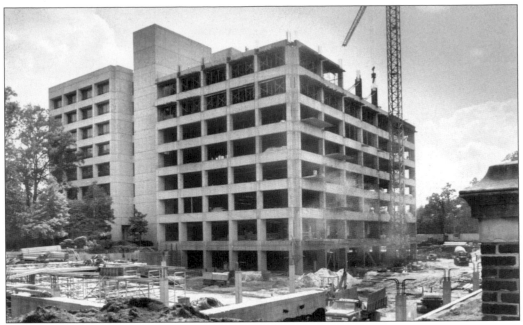

CLOSE-HIPP BUILDING, *c.* **1983.** A new building for the School of Business Administration was constructed in 1973; ten years later, an identical structure was built and connected to the first. The first building was named for H. William Close, an executive with Springs Industries, Inc. The second building was named for Francis M. Hipp, chairman of the Liberty Corporation and former president of the USC–Business Partnership Foundation.

JAMES KANE, 1970s. As dean of the School of Business Administration, James Kane led the efforts in 1974 to establish an innovative program: the master of international business (MIBS). The new degree was a joint program with the Institute of International Studies and sought to prepare students to compete in the global business arena. MIBS was first offered in 1974 and quickly became and remains a top-rated program in America.

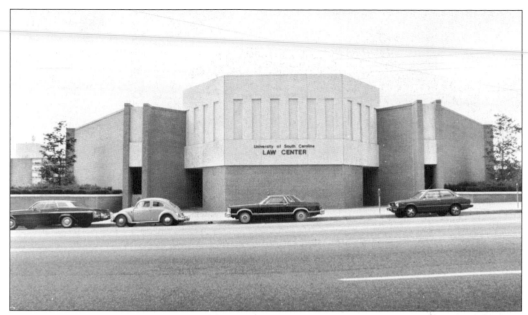

LAW CENTER, C. 1975. The contemporary-style three-building complex was built in 1973 to house the School of Law. The center's law library was named for professor emeritus Coleman Karesh, who taught law at the university from 1937 to 1972. A historical marker was placed in front of the Law Center to commemorate the South Carolina Commissioners Oak. The commissioners who were appointed to lay out the city of Columbia were said to have met in 1786 under an oak that grew at the site.

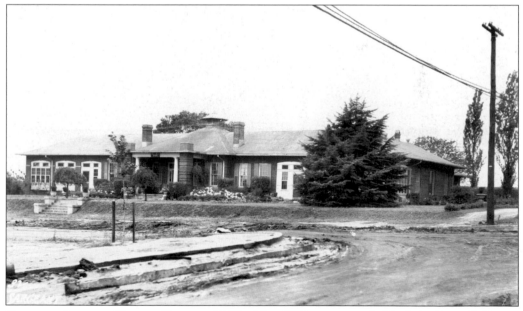

THOMSON STUDENT HEALTH CENTER, 1940s. The 1973 structure behind the Russell House replaced the first Thomson infirmary (above) located at the corner of Bull and Greene Streets and built in 1908. The first building was made possible through a bequest in memory of Carolina student A. Wallace Thomson by his aunt, Ann H. Jeter.

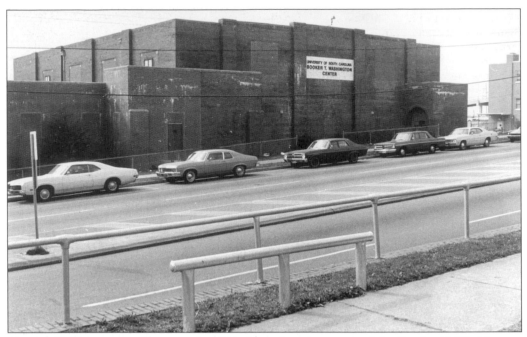

BOOKER T. WASHINGTON COMPLEX. In 1974, the university acquired the Booker T. Washington High School property, which was the first black high school in South Carolina. The oldest building in the complex was too costly to renovate, so the university tore it down and used the bricks to pave the Horseshoe drive. Additional portions of the school were torn down recently to make way for the construction of a new dormitory.

NURSING STUDENTS, c. 1975. In 1957, the department of nursing was removed from the College of Arts and Sciences and expanded into a full four-year school. In 1975, a new centralized facility was constructed, made possible through a significant bequest by the late Martha Williams Brice. The building was named in honor of the Williams and Brice families.

WILLIAM PATTERSON, 1977. When William Patterson became president of the university in 1974, he had a reputation as a master administrator. Patterson joined the university faculty in history and engineering in 1943 but soon moved into administration. He served as dean of administration and as the school's first provost. As president, he oversaw the establishment of the School of Medicine, renovations on the Horseshoe, and the major expansion of the library.

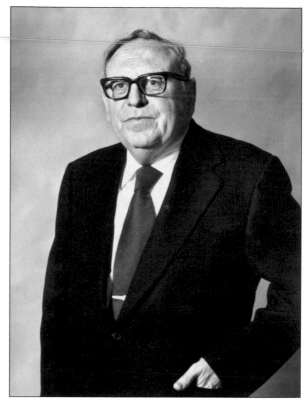

FIRST CLASS OF USC SCHOOL OF MEDICINE, 1977. After a decade of debate and a political battle with the Medical University of South Carolina (MUSC), USC opened its own School of Medicine in 1977. Much of the debate was whether a second school was necessary or if MUSC should be expanded.

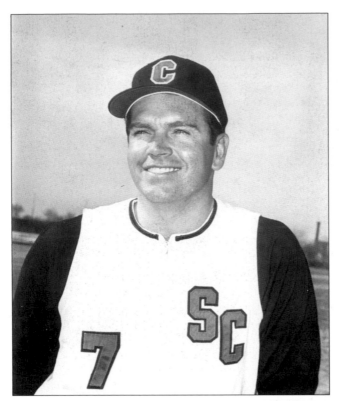

BOBBY RICHARDSON, *c.* **1975.** Former New York Yankee all-star Bobby Richardson became Carolina's first full-time baseball coach in 1969 and quickly generated excitement for the program. The 1974 and 1975 teams broke numerous school records, and the Gamecocks made trips to the College World Series in 1975 and 1976.

PARKING ATTENDANT AT WORK, 1970s. As long as there have been cars on campus, there have been complaints about parking. The dramatic expansion of the campus into urban areas in the 1960s and 1970s made parking problems a major issue for students and employees. Despite the addition of the ShuttleCock bus system in the late 1970s and the construction of garages, complaints about parking continue to abound.

PAM PARSONS, 1980. Pam Parsons coached the women's basketball team from 1977 to 1981. Until the passage of Title IX, women's sports at USC were at the intramural or club level. Title IX forced the university to fund women's athletics at a level that would ensure them the same kind of quality equipment, uniforms, training, and coaching as the men's teams.

STUDENT PLAYING PINBALL AT GOLDEN SPUR, 1980. As an alternative to the "unhealthy and unwholesome" Columbia bars, the board of trustees in 1970 decided to allow the development of an on-campus student lounge that sold beer. The Golden Spur opened in 1973 and became a popular spot for students and faculty. It closed in the mid-1980s when the minimum drinking age was raised to 21.

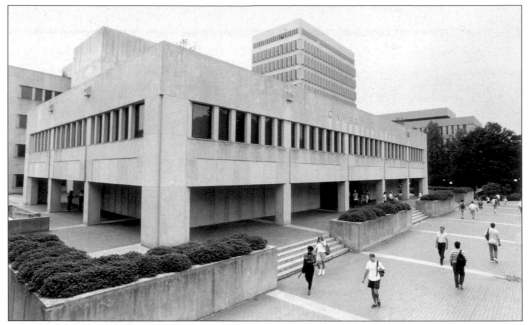

GAMBRELL HALL, C. 1980. The addition of Gambrell Hall to the campus was made possible by a gift of $1 million by E. Smythe Gambrell. Built in 1976, the building was named for Gambrell's sister, Dr. Mary Latimer Gambrell, former president of Hunter College of New York. Gambrell's location near the humanities buildings formed a U-shaped complex around the reflecting pool.

SWEARINGEN ENGINEERING CENTER. By the 1980s, the School of Engineering needed more space, and the Swearingen Engineering Center was built in 1987. The triangular building was named for John E. Swearingen, chairman of Standard Oil Company.

BIG SPUR AND COCKY AT A BASKETBALL GAME, 1980. Live gamecocks and a variety of gamecock costumes made appearances at football games over the years, but Big Spur was USC's first named mascot. The eight-foot-tall bird first appeared in 1978, but the costume didn't lend itself to interacting with the crowd. Cocky made his first appearance alongside Big Spur at the 1980 Homecoming game, but he did not make a good first impression. Fans who were used to seeing the tougher-looking Big Spur booed and jeered the softer and rounder gamecock. Cocky did not make another appearance until the women's basketball games, where he posed as "Super Chick" and wore large eyelashes and lipstick. Cocky returned as his original self in the 1981 football season, winning over the fans with his comical antics and interactions with the crowd; he has been extremely popular ever since. Cocky has been named National Mascot of the Year three times, in 1986, 1994, and 2003; he has been named to the Capital One All-America National Mascot team for the last three years.

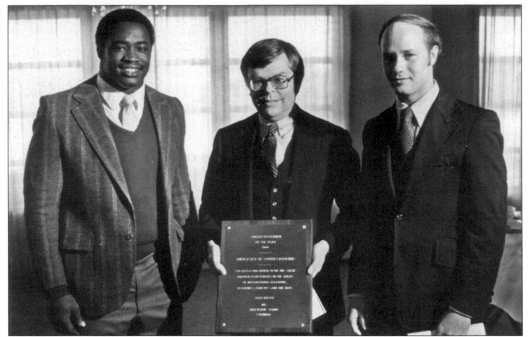

GEORGE ROGERS (LEFT), PRES. JAMES HOLDERMAN (CENTER), AND DANIEL DREISBACH, 1980. In this 1980 image, two USC students were recognized for their athletic and academic achievements. Running back George Rogers was awarded the Heisman Trophy for his outstanding performance on the football field. Daniel Dreisbach was the first USC student to win the prestigious Rhodes Scholarship since 1924.

JAMES B. HOLDERMAN, C. 1985. The dynamic, controversial James B. Holderman served as USC's president from 1977 to 1990. He brought USC increased international visibility and increased private giving to the university, and he established the South Carolina Honors College. Holderman resigned after being investigated for improper use of university funds.

HENRY KISSINGER AT A RECEPTION, 1980s. Former secretary of state Henry Kissinger was among the international diplomats that visited the university in the 1980s, when USC hosted a North Atlantic Treaty Organization conference on the future of the western alliance.

ARPAD DARAZS, LATE 1980s. Hungarian native Arpad Darazs joined the USC faculty in 1966 as professor of music and director of choral activities. His guidance quickly brought Carolina's choral program worldwide acclaim. Darazs also served as the music director of the Columbia Philharmonic Orchestra and founded the Palmetto Mastersingers. Students named him an outstanding teacher three times in his career. He taught at USC until his death in 1986.

RONALD REAGAN ON THE HORSESHOE, 1983. In 1983, Ronald Reagan became the first U.S. president to visit USC since William Howard Taft in 1909. His visit also marked the first time the university awarded an honorary degree to an incumbent chief executive. After the ceremony, Reagan was presented with a USC sweatshirt and cap. Reagan returned to the university for a Caribbean conference in 1984.

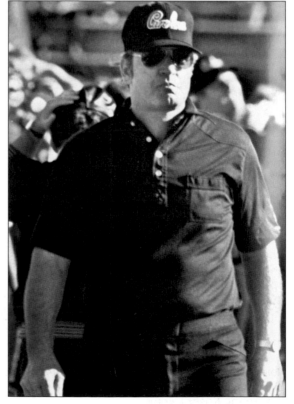

JOE MORRISON, 1983. Known as "the man in black" for his all-black attire, coach Joe Morrison came to Carolina in 1983. One year later, his football team achieved what came to be known as the "Black Magic" season. A heart-breaking loss to Navy ruined USC's shot at a Number 1 ranking, but the team finished the season with a close victory over Clemson and a Number 11 rank.

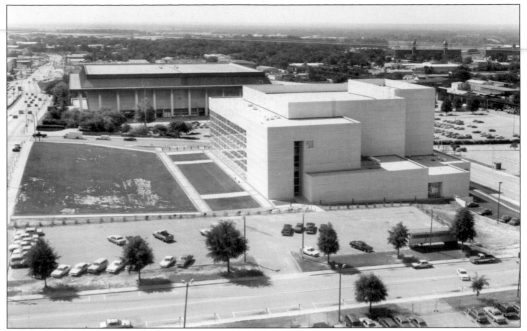

KOGER CENTER, 1988. The Koger Center for the Arts was completed in 1988 to address the university's need for a performing arts facility. The building was made possible by a gift from nationally known art collectors and patrons Ira and Nancy Koger, as well as funds from the City of Columbia, Richland County, and the university.

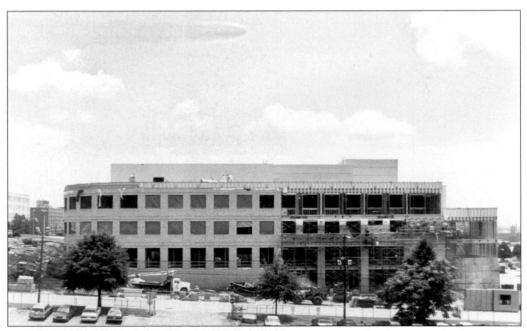

CONSTRUCTION OF THE MUSIC BUILDING, 1994. By the 1980s, the School of Music had outgrown its facilities in McMaster College. A state-of-the-art new building was constructed in 1994 next to the Koger Center.

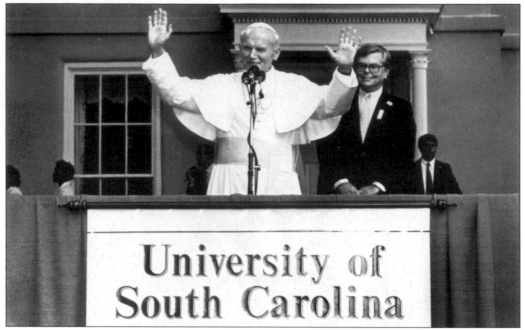

POPE JOHN PAUL II ON THE HORSESHOE (TOP) AND IN THE POPEMOBILE (BOTTOM), 1987. During the 1986–1987 academic year, USC sponsored an "Ecumenical Year" that brought world religious leaders to the campus. Greek Orthodox Archbishop Iakovos received an honorary degree at the August 1986 commencement ceremonies, and the Reverend Billy Graham addressed the December 1986 graduating class. The year was capped off with a visit from Pope John Paul II in September 1987. Over 10,000 people crowded onto the Horseshoe, and USC students greeted the Pope by chanting, "John Paul Two, We Love You!" He told the crowd, "It is wonderful to be young, it is wonderful to be a student in the university, it is wonderful to be young and a student at the University of South Carolina." The Pope also conducted a service at Williams-Brice Stadium for over 60,000 people.

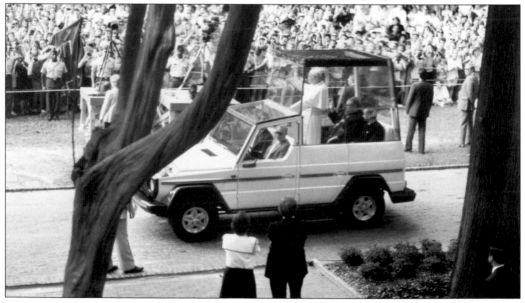

WOMEN'S TRACK TEAM, 2002. Since 1990, USC has been marked by athletic and academic accomplishments. Carolina athletics reached several milestones since 1990, including the football team's first bowl game victory in 1995, followed by back-to-back victories in the Outback Bowl in 2001 and 2002. The baseball team won two SEC championships and competed in the College World Series three times between 2000 and 2004. The year 1995 also marked the first varsity game by the USC women's soccer team. In 2002, thirty years after Title IX, the women's track and field team brought home the university's first-ever national championship. The USC men's and women's track teams have also produced Olympic medalists. University students have also received a multitude of prestigious academic honors in recent years, including Fulbright, Truman, and Marshall scholarships. In 1999, Caroline Parler became USC's first Rhodes scholar since 1983.

EAST QUAD DORMITORY (TOP), AND CAROLINA PLAZA DEMOLITION, 2006 (BOTTOM). In the 1990s, the university began another period of physical expansion. The architectural style of the new buildings moved away from the ultramodern looks from the 1970s and back to a more traditional style. In 2004, a new building was started to consolidate the offices of the Arnold School of Public Health into one building. In 2006, the university imploded the old Carolina Plaza hotel (below). The Arnold School of Public Health is in the foreground.

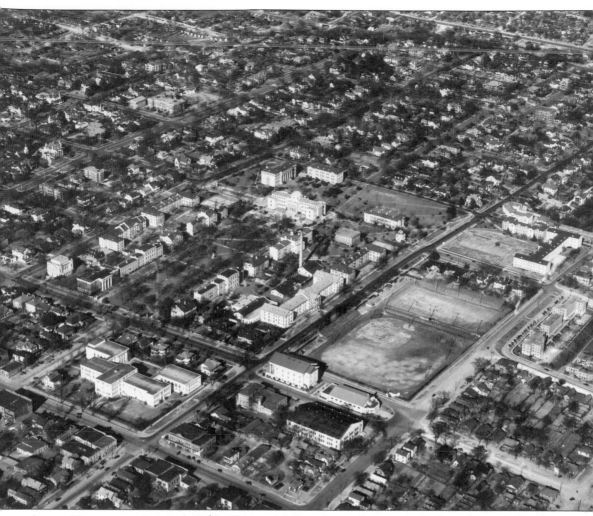

AERIAL VIEW OF THE CAMPUS, 1940. This aerial shot shows the campus before the periods of massive expansion that started in the 1950s. The road at the top of the photograph is Harden Street. The empty spaces to the right of Greene Street are Melton and Davis Fields, where the Russell House and Thomas Cooper Library would be built.

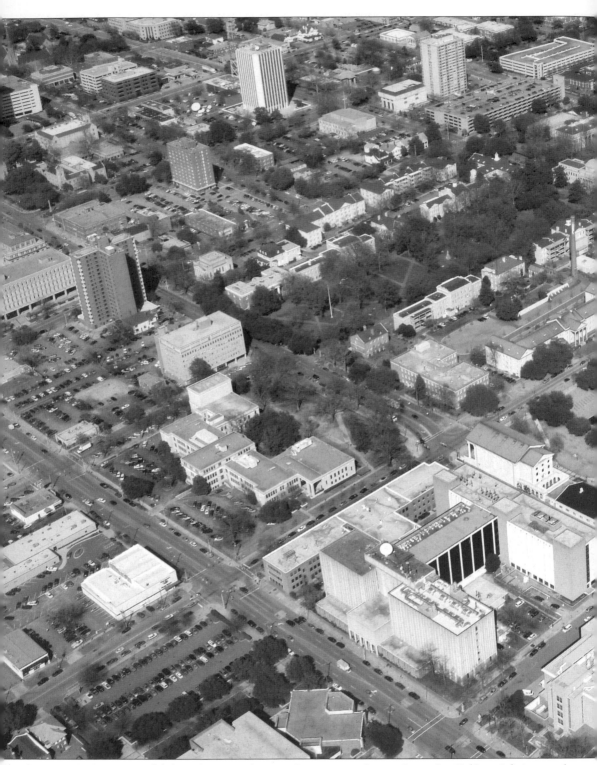

AERIAL VIEW, 2006. This photograph was taken at a similar angle to the 1940 aerial view and shows the expansion of the East Campus into Columbia neighborhoods. Harden Street is still

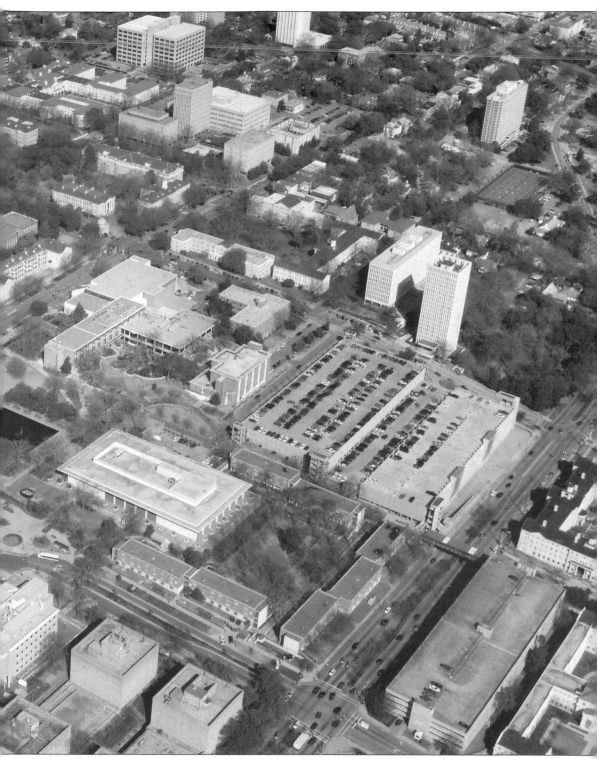

visible at the top of the image. The university's new master plan for campus development places most of its future expansion toward the Congaree River.

BIBLIOGRAPHY

Buildings of the Columbia Campus, University of South Carolina. Columbia: University of South Carolina Press, 1990.

Faithful Index: The University of South Carolina Campus. Columbia: University of South Carolina Press, 1976.

Hollis, Daniel. *University of South Carolina*. 2 vol. Columbia: University of South Carolina Press, 1951–1956.

Lesesne, Henry H. *A History of the University of South Carolina, 1940–2000*. Columbia: University of South Carolina Press, 2001.

Vertical Files, University Archives, University of South Carolina.

INDEX

ACROSS AMERICA, PEOPLE ARE DISCOVERING
SOMETHING WONDERFUL. *THEIR HERITAGE.*

Arcadia Publishing is the leading local history publisher in the United States. With more than 3,000 titles in print and hundreds of new titles released every year, Arcadia has extensive specialized experience chronicling the history of communities and celebrating America's hidden stories, bringing to life the people, places, and events from the past. To discover the history of other communities across the nation, please visit:

www.arcadiapublishing.com

Customized search tools allow you to find regional history books about the town where you grew up, the cities where your friends and family live, the town where your parents met, or even that retirement spot you've been dreaming about.